A–Z

OF

GATESHEAD

PLACES - PEOPLE - HISTORY

Sandra Brack, Margaret Hall
& Anthea Lang

AMBERLEY

First published 2019

Amberley Publishing
The Hill, Stroud, Gloucestershire, GL5 4EP
www.amberley-books.com

Copyright © Sandra Brack, Margaret Hall and
Anthea Lang, 2019

The right of Sandra Brack, Margaret Hall and
Anthea Lang to be identified as the Authors of
this work has been asserted in accordance with
the Copyrights, Designs and Patents Act 1988.

ISBN 978 1 4456 9119 0 (print)
ISBN 978 1 4456 9120 6 (ebook)

British Library Cataloguing in Publication Data.
A catalogue record for this book is available
from the British Library.

Typesetting by Aura Technology and Software
Services, India. Printed in Great Britain.

Contents

Introduction

From Abbot to Zilliacus, *A–Z of Gateshead* is a tapestry of Gateshead's history and looks at a variety of subjects from times long gone up to events today.

Gateshead has often been in the shadow of its near neighbour Newcastle and people's realisation of Gateshead's historic past has suffered as a result. And it certainly does have a history – from turbulent times with the murder of Bishop Walcher in 1080, through disasters such as cholera epidemics and the Great Fire of 1854, until, almost with a sigh of relief, we come to today's regeneration and with it a growing sense of Gateshead's historic importance.

Gateshead was a town of great contrasts and expanded considerably in terms of population during the nineteenth century. This caused problems of overcrowding and sanitation, which led to Lord Londonderry referring to Gateshead in 1832 as a dirty back lane leading to Newcastle. That castigation, while probably true at the time, stuck for more years than it was entitled to.

The town's new governing body, Gateshead Borough Council, which took over from the medieval form of government, the Four and Twenty in 1835, were at first overwhelmed with these problems, but gradually overcame them with buildings such as the Dispensary and the Oakwellgate Baths and Washhouses, which tried to improve the health and hygiene of inhabitants of the borough. Bensham Grove, one of Gateshead's fine houses, played host to many of the important Victorian visitors of the day, including William Morris, one of the leaders of the Arts and Crafts movement.

Famous people who have lived in or been born in Gateshead are often commemorated with blue plaques, and in Gateshead itself there are over thirty of these. Gateshead Local History Society, established in 1964, recently took over this initiative from the council.

Today, despite many setbacks, Gateshead can be seen to be a thriving town, and one that is rightly proud of its heritage. Regeneration and investment have seen a programme of public artworks erected throughout the borough, and the Gateshead Garden Festival of 1990 showed local people and visitors just what could be done with an area of derelict wasteland. Buildings such as the Baltic Centre for Contemporary Art and Sage Gateshead have proved that culture is very alive in the town, while the iconic *Angel of the North* statue welcomes visitors coming to the town from the south with its outstretched wings.

GLHS
Gateshead Local History Society

A

Abbot Memorial School

The Abbot Memorial School was founded by the widow of John George Abbot – the son of John Abbot, who had founded what became known as the Park Ironworks. Catherine was well known for her charity, having also funded the old Northern Counties Orphanage on the Great North Road. She provided £9,473, which was £2,000 more than the building cost, and laid the foundation stone on 17 October 1867. The school opened as an industrial school in January 1869 for 100 boys and fifty girls, although from 1907 it was boys only. These were children who had either already committed crimes or were thought to be potential criminals. The girls were trained for domestic service, while the boys learnt a trade in classrooms and workshops. The school was very successful, particularly in its early years. Between 1882 and 1884, out of eighty-seven boys and girls discharged, seventy-five were described as 'doing well',

Abbot Memorial School, *c.* 1908.

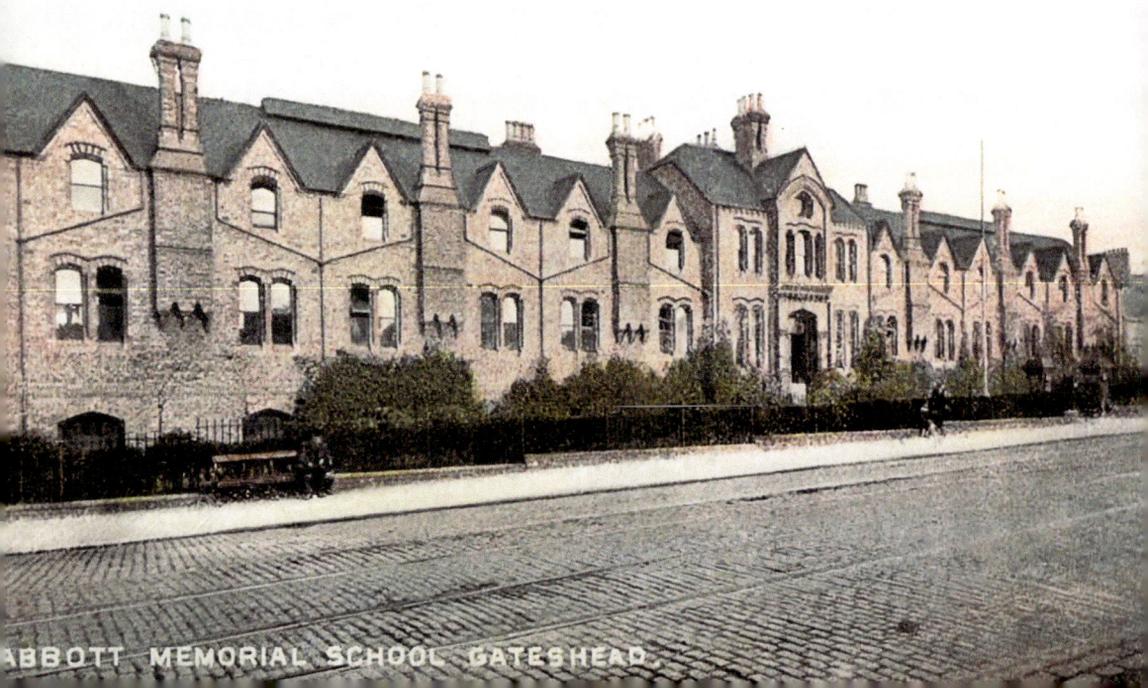

four had died, five were unknown and only three were now leading what was termed 'doubtful lives'. The boys had their own gardens and sometimes went to summer camp – in 1921 they were taken to Warkworth. However, the school was criticised in its later years, as many of the boys simply ended up in the pits.

The establishment closed on 31 March 1930 when the remaining boys were transferred to Axwell Park at Blaydon, although a trust fund continued to support many boys and girls.

Anchorage

The Anchorage was built onto the north wall of the chancel of St Mary's Church, and for much of its life was used as a school. The name may derive either from the fact that a cell was built here to house an anchorite (a female hermit) in 1340, or may be a reference to the dues paid for vessels anchoring in the Tyne nearby.

Anchorage building shown at the right of St Mary's Church.

It is recorded in the parish registers of 1658 that the churchwardens were authorising money for work at the Anchorage. At that time, the Four and Twenty, who were the forerunners of the local council, held their meetings there. By 1651 it was being used as a school, and in 1701 Theophilus Pickering, rector of St Mary's, left £300 to maintain a free school in Gateshead. This was used to maintain the Anchorage, with children being taught Latin, Greek, account keeping and navigation. There was a fee to attend the school, although fifteen children were given free places.

After the local council was established in 1835 with George Hawks as mayor, the new borough council held their first meetings at the Anchorage. The school closed in 1869, and the room was then used for parish business. The Anchorage was badly damaged in the great fire of 1854 and was largely rebuilt; however, following a further fire in 1983, the building was in such a state of disrepair that it had to be demolished.

Angel of the North

Today one of the North East's most iconic images, this statue continues to divide opinions, although there is no doubt of its continuing popularity. Designed by Antony Gormley (it was based on a cast of his body) and unveiled in February 1998, it has become the best known of Gateshead's public art sculptures, with funding provided largely by the National Lottery. The *Angel* is situated at the southern end of Gateshead, near Birtley, overlooking the A1 and A167, and is clearly visible from both road and rail. Due to its exposed location (the former pithead baths of the Team Colliery) it was built to withstand winds of over 100 mph, and its foundations go 21 metres below ground. Using weather-resistant steel, the statue is 20 metres tall and has wings measuring 54 metres across. Constructed in Hartlepool, the *Angel* was brought by trailer on a night-time journey lasting five hours. Today, the sculpture attracts 150,000 visitors each year.

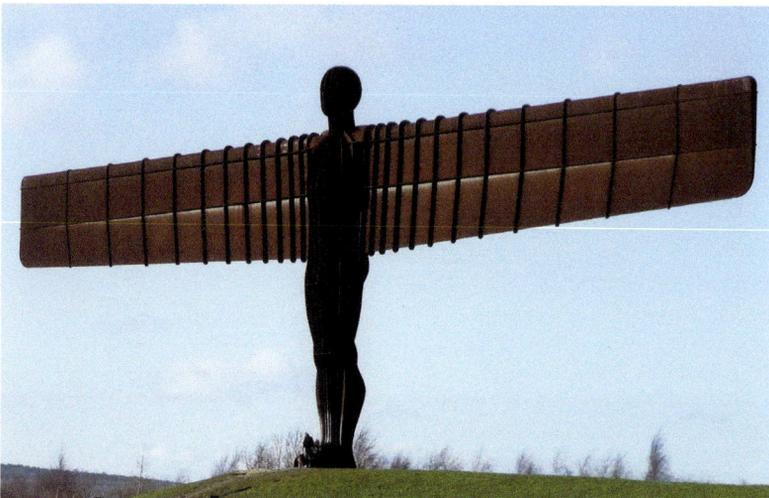

Angel of the North.

B

Baltic Centre for Contemporary Art

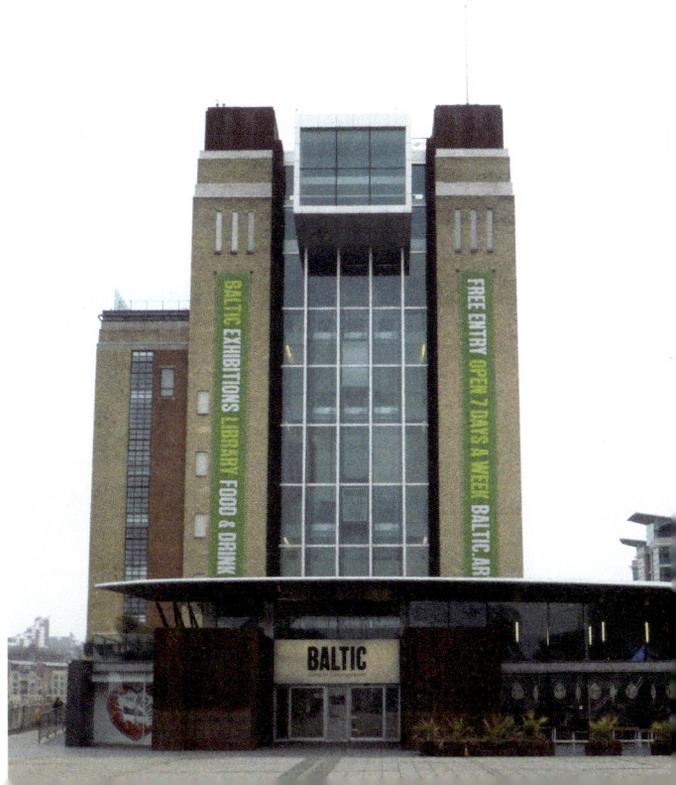

When Joseph Rank built a new flour mill on Gateshead quayside he could not have had any notion that within fifty years the original silo building would have a surprising new use. The building opened in April 1950 at a cost of £1,500,000, and was extended in 1957 with the addition of an animal feed mill. The mill employed 300 people and was capable of despatching 240 tons of grain per hour. Despite this, it closed in 1981. Most of the complex was demolished, with only the silo remaining as a reminder of the mill. In 1991, Northern Arts began to discuss the idea of promoting contemporary visual art on Tyneside and building alterations began in 1998, with only the north and south façades of the building being retained. It opened on 13 July 2002, and the first exhibition was called B OPEN. It was a huge success, attracting over 35,000 visitors

Baltic Centre for
Contemporary Art.

in the first week. Spread over six floors and three mezzanine levels, the building contains 3,000 square metres of arts space. The centre has no permanent collection, with constantly changing displays. As well as art, the building contains studios, lecture space, a shop, library and archive, and a rooftop restaurant. From the upper levels there are panoramic views of the river and Gateshead and Newcastle quaysides.

Bensham Grove

The house was bought as a country cottage by Joseph Watson, a Quaker and Newcastle cheesemonger, in the early 1800s. Situated on Bensham Road, Gateshead, Bensham Grove has seen many changes both in use and architectural features. Joseph and his son Joshua, then later his grandson Robert Spence Watson, enlarged the house, resulting in a mix of Georgian and Victorian features. Robert in particular made many changes to Bensham Grove, with firms such as Morris & Co. being used to install stained glass, fireplaces, tiles and carvings in the then fashionable Arts and Crafts style. During Robert and his wife Elizabeth's time at Bensham Grove the house was visited by many artists, craftsmen, educationalists, reformers, poets and politicians.

Robert died in 1911, and after Elizabeth's death in 1919 the house became an educational settlement under the wardenship of Miss Lettice Jowett. The hall, which was added after this time, became the home of Tyneside's first children's nursery, which opened in 1929.

Bensham Grove.

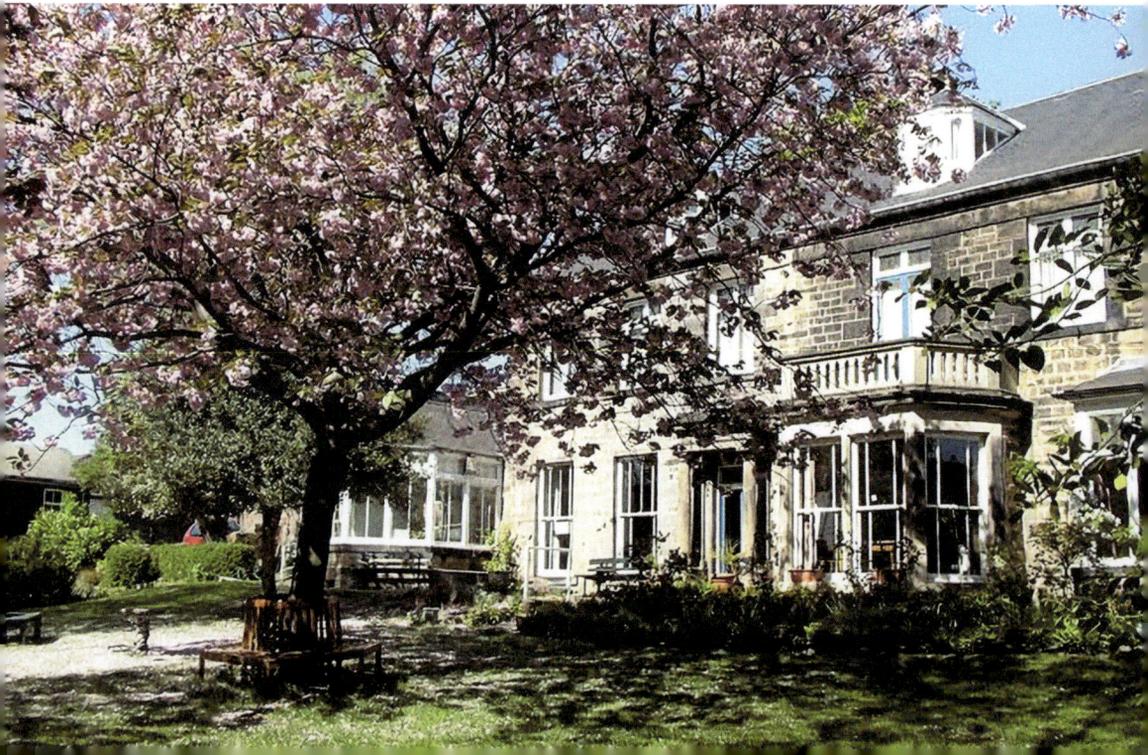

The house is Grade II listed and has recently undergone a major restoration. It remains a thriving adult learning centre, with an emphasis on arts and crafts.

Booth, William and Catherine

William was born in 1829 in Nottingham to an impoverished housebuilder. He grew up in poverty after the death of his father and turned to Methodism, believing it to be more concerned with social issues than the Anglican church his family attended. It was after hearing an American revivalist preaching that he started preaching to the poor himself in the open air. By 1852 he was working as a full-time Methodist preacher in Spalding, Lincolnshire. Here he met a devout Christian called Catherine Mumford who shared his evangelical interests. They married in 1855, and three years later William became a New Connexion minister at the Bethesda Chapel, Melbourne Street, in Gateshead. Here his persuasive style of oratory attracted large crowds. The couple set up home in Woodbine Terrace. Catherine, a feminist, disagreed with William's views on female preachers. Catherine first started to preach in 1860 at the Bethesda Chapel. At her first sermon it was said that 'the chapel was crowded to the doors and people sat on the very window sills'. Catherine's sermon was so impressive that William changed his views on female preachers. The Booths left Gateshead in 1861 for London's East End, where they later formed the Salvation Army.

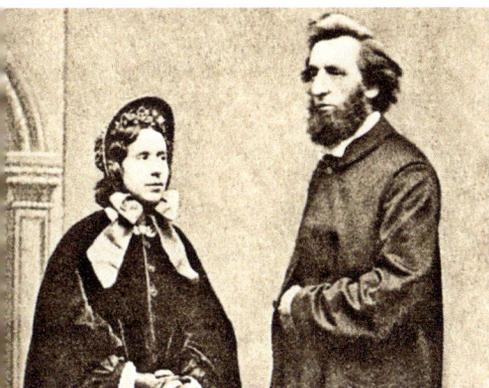

Above: William and Catherine Booth.

Right: Blue plaque to William and Catherine Booth.

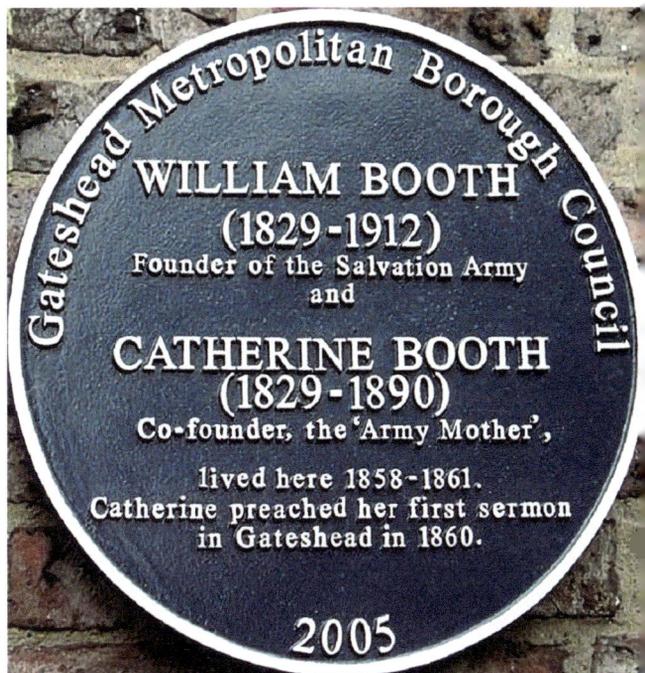

Gateshead Metropolitan Borough Council

WILLIAM BOOTH
(1829-1912)
Founder of the Salvation Army
and

CATHERINE BOOTH
(1829-1890)
Co-founder, the 'Army Mother',

lived here 1858-1861.
Catherine preached her first sermon
in Gateshead in 1860.

2005

Brandling Junction Railway

Robert and John Brandling came from a noted coal-owning family and owned extensive lands in the area. They formed the Brandling Junction Railway in 1834 to connect Gateshead with South Shields and Monkwearmouth – all potential outlets for the sale of their coal.

Construction began in 1836, and the first section of the line opened on 15 January 1839. It ran from near Redheugh at the west of Gateshead to Oakwellgate, near the town centre. On 19 June 1839, the next section opened from South Shields to Monkwearmouth, and the final section, from Gateshead to Cleadon Lane, opened for mineral traffic on 30 August 1839 and for passengers on 5 September 1839. This date is regarded as the real opening of the line.

Although at first the railway was successful, within a few years it was discovered that the Brandlings were greatly inflating their supposed profits and the company was bought out in August 1844 by George Hudson 'the Railway King', who then transferred ownership to the Newcastle & Darlington Junction Railway. Oakwellgate station, the north terminus for the Brandling Junction Railway, closed on 1 September 1844 after a short life of just five years. Today this has a new use as the upper-level carpark for the Sage Gateshead.

Brandling station, Felling.

Breweries

In the eighteenth century the Barras family of yeomen farmers made their wealth from wayleaves – rents charged for coal being transported across their land. John Barras established a brewery in Gateshead in 1770 with his partner William Johnston; and by 1799 he needed a new business partner. John Barras died in 1811 at the age of sixty-six and his son, also John, took over the running of the brewery. In 1821 it was decided to give up making wine and spirits to concentrate on brewing ale with John Russel, becoming Barras & Co. By 1824 the Gateshead brewery was producing more than 40,000 barrels per year.

John Barras lived at Farnacres, near Lobley Hill. By 1848, Charles Reed, who had married into the family, became involved with the brewery, leasing it from the Barras Trust in 1861. After the trust was wound up in 1882, the site was sold to the North Eastern Railway. Charles Reed took over the running of the public houses associated with the brewery and moved into the vacant Tyne Brewery in Newcastle. In 1890 the Barras brewery amalgamated with a number of local breweries to become Newcastle Breweries.

Another brewery in Gateshead was that of the Turks Head, which was established by Isaac Tucker towards the end of the eighteenth century. This was situated near the foot of High Street. After the death of his father, Thomas took over the management and it is believed that he was the first to introduce copper as the sole material for brewing utensils. The brewery was demolished in 1970 for road improvements.

In 1840 John Rowell founded a brewery on land to the east of the High Street. Rowells owned the large Crown Hotel at No. 143 High Street, which also served as the company's offices. The brewery was enlarged in 1913, taken over by Newcastle Breweries in 1959 and wound up in 1960.

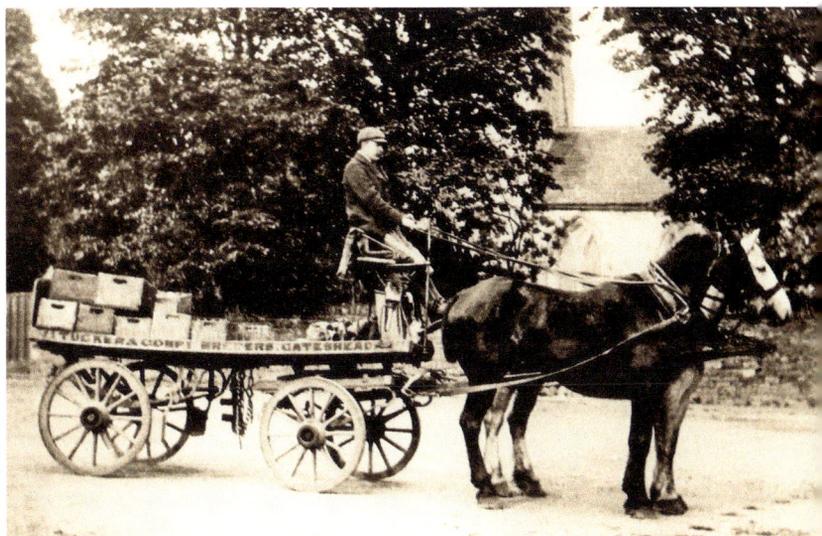

Tucker's delivery wagon, *c.* 1900.

C

Cenotaph

The cenotaph was unveiled on 14 May 1922, to commemorate the 1,700 Gateshead men who lost their lives in the First World War. It was designed by John W. Spink of Kingston upon Thames and built by Alexander Pringle of Gateshead. It was paid for largely by public subscription and cost £5,500. Built of Heworth Burn blue stone, the cenotaph stands just over 33 feet from pavement level. A bronze panel above the door shows a warrior 9 feet high representing 'Manhood'. He stands in an attitude of defence, lightly resting upon his unsheathed sword. The portal over the teak door is inscribed '*Mors Janua Vitae*' (Death is the Gate of Life). Inside is a lectern upon which once stood the Book of Remembrance. After a theft and subsequent recovery, the book is now held in Gateshead Central Library. The cenotaph is Grade II listed, and a service and march past takes place each year on the nearest Sunday to 11 November.

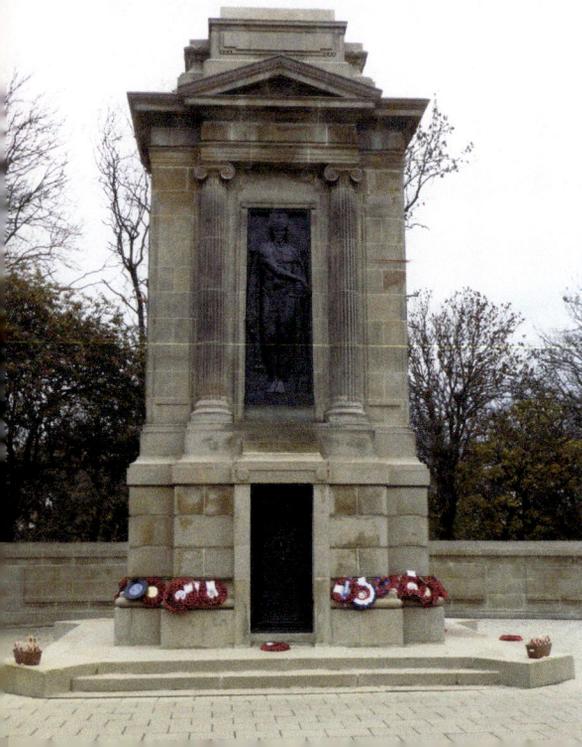

Cenotaph, Shipcote.

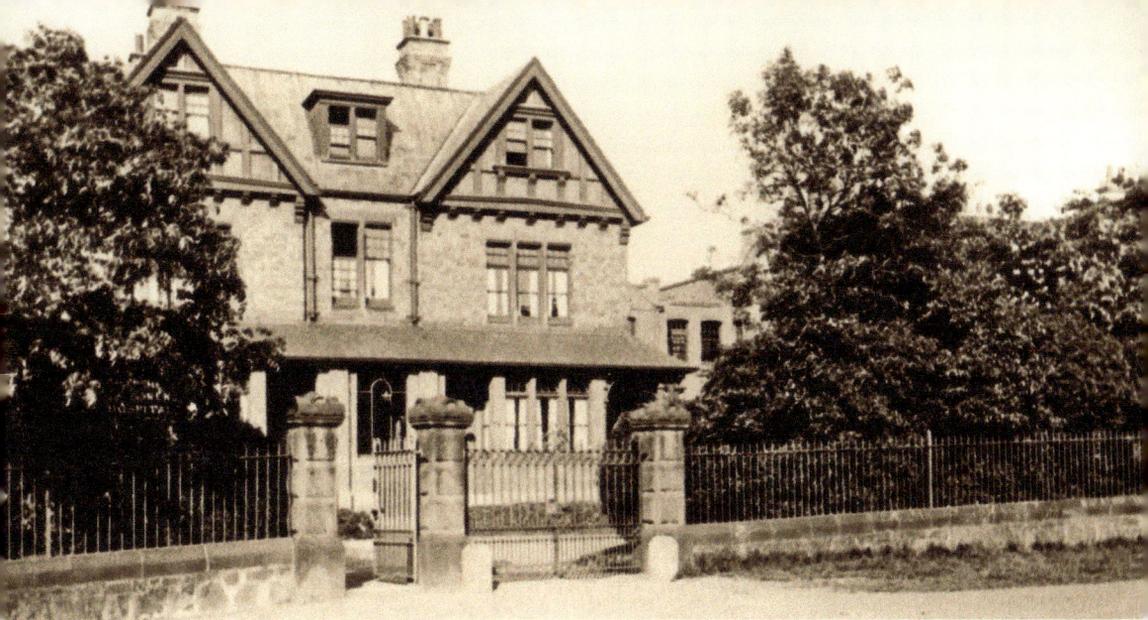

Children's Hospital, Dryden Road.

Children's Hospital

The Royal Jubilee Children's Hospital opened in Gateshead on 1 October 1888 with eight beds. It was paid for largely by legacies, local workmen and various clubs, with Lord and Lady Northbourne contributing both the land on which it was built and a generous donation of £1,250. In its first full year, seventy-five inpatients and 754 outpatients were treated, and it proved so successful that the foundation stone for a new extension was laid on 9 October 1907. By then, 2,369 inpatients and 16,748 outpatients had been treated. The extension provided two operating rooms, bath and lavatory annexes and two small wards with offices. As a result, the number of operations rose from nine in 1888, to 165 in 1907. Queen Elizabeth visited in February 1939 and was so impressed that her daughter (the present Queen) later sent a large piece of her birthday cake 'with Princess Elizabeth's best wishes to the children of the hospital'. By 1956, many children were being sent to other hospitals with more specialised facilities, which resulted in many beds lying empty. In 1959, an antenatal outpatients opened at the Children's Hospital and the building eventually ended its days as a clinic for the deaf.

Clay Pipes

The production of small clay pipes for smoking tobacco had been a feature of Gateshead from the seventeenth century, when William Sewell was listed as a pipe-maker in 1646; by the nineteenth century their manufacture had become a popular home industry. New pipes were always needed as they were relatively fragile and frequently broke. In the early nineteenth century there were at least ten pipe-makers,

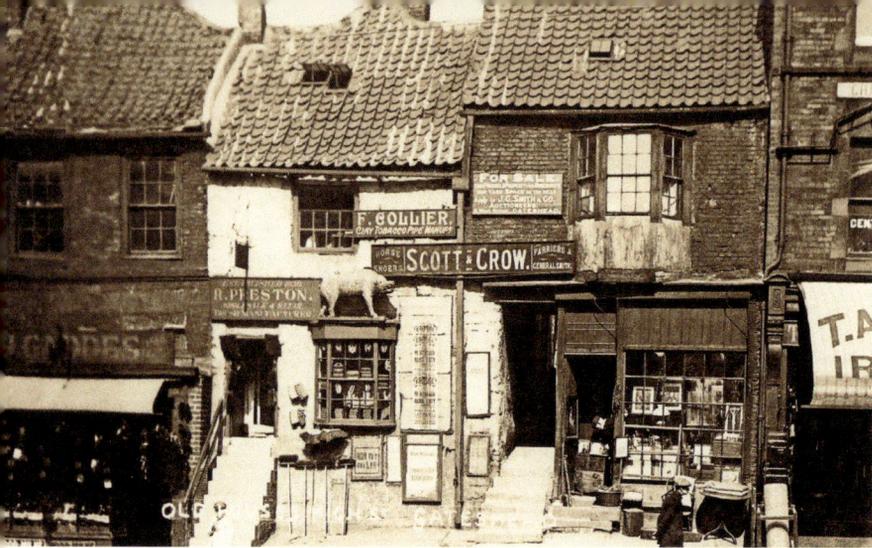

F. Collier, clay tobacco pipe manufacturer.

and even by the end of it six were still in business, using white china clay imported from Devon. However, the rise of the cheap cigarette meant the demise of the clay pipe, so soon no one was making clay pipes in Gateshead any more. Joe Hardy is regarded as Gateshead's last clay pipe producer – he made his final pipe in 1935. Although most of the pipes were plain, others were decorated with a variety of images.

Cotesworth, William (*c.* 1668–1726)

Nicknamed 'Black William' and one of Gateshead's most colourful characters, William Cotesworth was born in Eggleton in Teesdale to a yeoman family. Aged fourteen, he was apprenticed to Robert Sutton, a tallow and coal chandler who had a shop on Bottle Bank, Gateshead. Within seven years William had established his own business, and ten years later, in 1699, he married Hannah Ramsay, a goldsmith's daughter from Newcastle.

This was an extremely useful match for Cotesworth, who was now able to begin expanding his trading enterprises. He began dealing in grindstones, lead, glass bottles, salt and swords, which were made at Shotley Bridge, and by 1715 he was the greatest salt trader in England. However, his greatest success was in coal, especially in the buying up of wayleaves. This meant that he controlled the land between the mines and the staithes. The wagonways usually crossed land either owned or leased by Cotesworth, and the wayleave rents had to be regularly paid. He became principal agent to the Grand Allies – the formidable coal owners in Gateshead and Whickham.

He persuaded his wealthy brother-in-law William Ramsay to buy the manors of Gateshead and Whickham, with Cotesworth himself becoming Lord of the Manor of Gateshead and Whickham after William Ramsay died in 1719. He now owned the Park estates where he rebuilt the manor house of Park House. Due to his business methods, Cotesworth had many enemies, and in 1725 his gardener and butler attempted to poison him. They were eventually imprisoned for this and forced to do penance on certain days every year. William Cotesworth died in 1726.

D

Davies, Emily (1830–1921)

Emily was born in Southampton but spent much of her childhood in Gateshead, where her father became rector in 1840. After her father's death in 1862 she moved to London, where she became involved with women's rights and was one of several women who unsuccessfully petitioned Parliament to grant women voting rights. She also campaigned for improved education for women, including their right to gain teaching qualifications and degrees.

In 1869, she led the founding of Girton College, Britain's first women's college in Hitchin, Hertfordshire, although it later moved to the outskirts of Cambridge in 1873. Emily was mistress of the college from 1873 to 1875 and then acted as its secretary until 1904. She was awarded an honorary Doctor of Laws from Glasgow University in 1901. Emily Davies died in 1921, by which time she had seen at least some women get the vote in 1918. A blue plaque to Emily can be seen on the former rectory wall on Bensham Road.

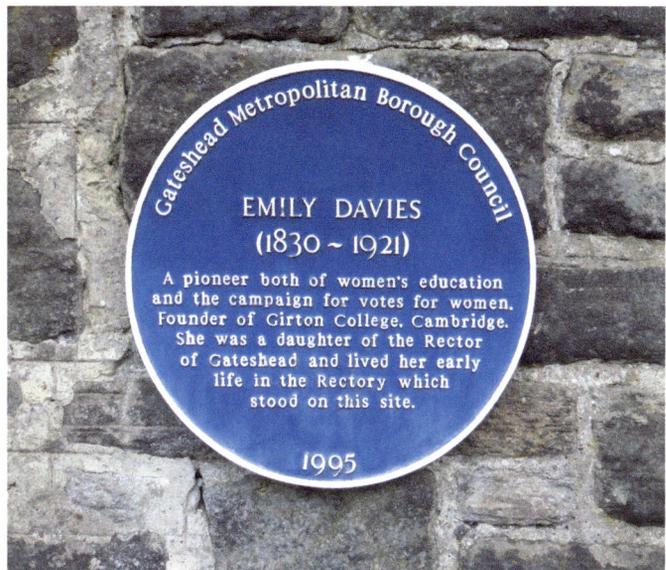

Emily Davies blue plaque.

Dodds Dene,
Low Fell.

Denes

Dene, dean, den and don are all suffixes used to describe a valley normally narrow and wooded. Gateshead is blessed with many denes, historically used for many purposes. These include Allerdene to the south of the town, which was home to several pits and Allerdene colliery. Next we have Chowdene, which is referred to in the Newcastle Courant, which mentions a mill for rent belonging to the Ravensworth estate. Chowdene also housed the Sun Inn as well as several large houses, including Glenbrooke, Ravenswood and Earlswood. The next dene along is Dodd's Dene, known locally as Dickies Dene after the mine owner Dickie Fenwick who supposedly galloped down it with coat tails flying behind him on his way to his pit. Close by is Alumwell Dene. Alum is an astringent compound used in dyeing, tanning and papermaking. Some of the grand houses in Gateshead had their own denes, including Whinney House. Here, the Joicey family built a bridge across the dene that led to St Helen's Church in Low Fell, giving access to the Joicey family pew.

Derwent Tower

Known locally as 'the Rocket', Derwent Tower was designed by the Owen Luder Partnership on behalf of Whickham Council, which controlled the Dunston area of Gateshead.

'The Rocket', aka Derwent Tower, 1983.

The original brief was for three high-rise blocks of at least twenty-two storeys, but due to adverse ground conditions on-site the decision was made to build one tower, with the rest being low-rise blocks of two to five storeys.

Despite the architect's advice against constructing a high-rise building on the site, the council decided to go ahead. Following further consultations and explanatory models of the foundations with specialists, construction of the foundations began in February 1968, and the tower was completed in March 1971. Unfortunately, the building suffered many faults, and in 2007 residents were moved out. On 17 August 2009 the tower failed to gain listed-building status. In January 2012 demolition began, which was completed in September 2012.

Dispensary

In 1831 after an outbreak of cholera in Gateshead, which broke out in Bottle Bank and mainly affected the poor, some of the more well-off residents of the town decided that it was time to set up some form of healthcare to treat those who could not afford it themselves.

The Dispensary opened for business on 12 April 1832 in a house on the High Street at an annual rent of £16. It aimed to put medicine and advice within the reach of

the poor. The initial donations of £686 paid for the treatment of 2,394 patients in the first nine months. Money was raised from local firms, wealthy residents, local churches having collections, and an annual ball.

The general upkeep was largely financed by subscribers who paid an annual fee, which entitled them to free medical treatment for themselves, their servants and also provided them with letters to give to the deserving poor. Patients had to be recommended to come to the Dispensary, except in an emergency. In its first ten years the Dispensary gave medical relief to 35,926 persons, of whom 33,610 were cured. Because the workload had risen so much, extra staff were taken on.

By the mid-1840s it was beginning to be realised that the ill health of the poor was caused largely by the general unsanitary conditions in which they lived. In 1848 cholera appeared again, but not so virulent this time, attributed in some degree to the greater sanitary precautions.

In 1855 the building in Nelson Street that we know as the Dispensary today, which had been built in the 1830s as a private house for the Swinburne family, was bought by Gateshead Corporation. This served as the Dispensary until 1946.

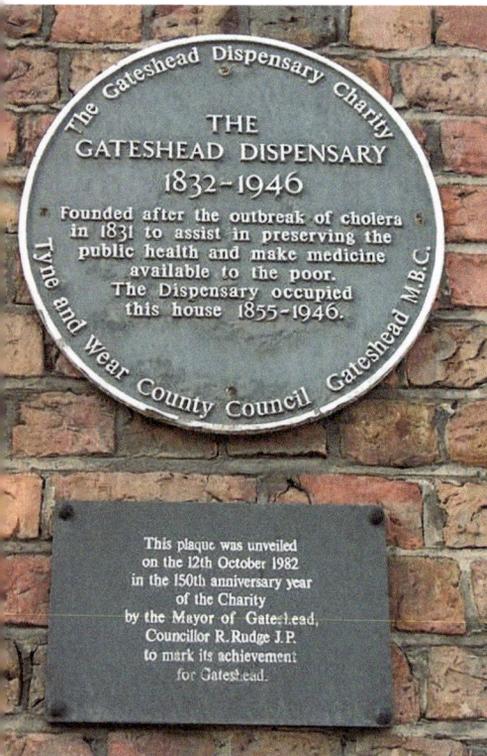

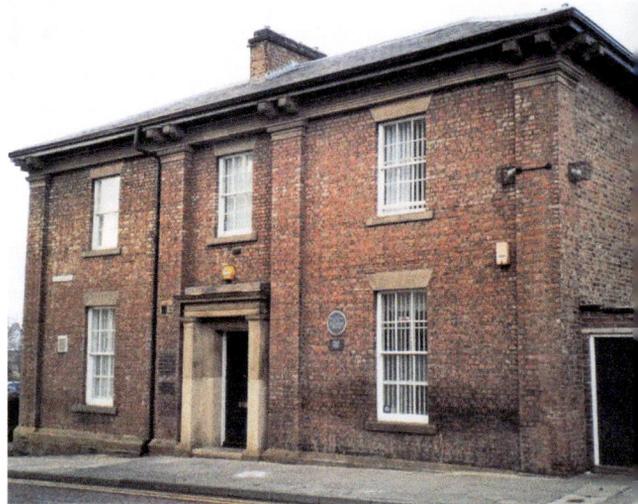

Above: Dispensary.

Left: Dispensary blue plaque.

E

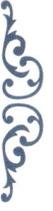

Ede, William Moore (1849–1935)

William Moore Ede was born in London and became rector of Gateshead in 1881. He was a great social reformer, advocating pensions for older people long before the idea had been thought of as a national scheme. He became chairman of Gateshead's School Board and realised that many children were coming to school hungry and remaining so all day. He travelled to Sweden in 1884 to see an example of a school dinner system and on his return he put a 1d dinner system into operation in Gateshead – even inventing a special oven to cook all the dinners. For their 1d children could have a baked potato at lunchtime, followed by either a raisin or apple pudding. He left Gateshead in 1901 to become rector of Whitburn and in 1908 was elected Dean of Worcester. He retired from that post in 1934 and died the following year. He was greatly loved by the people of Gateshead.

Empress Cinema

This cinema, described as the ultimate fleapit (hence its nickname of 'Loppy Lloyds'), was opened in a former warehouse and was entered through a long passage between two shops. The original architect was Lawrence Hill Armour and he designed it as the Coronation Hall. However, his design was flawed as the building only had one exit. This meant the opening had to be delayed until another exit could be created. It finally opened on 13 May 1910 and, despite its later nickname, it was intended to provide luxurious accommodation with a pit, grand circle and a café, which provided teas for the better class of patrons. It was taken over in 1911 and its name was changed to the Empress. During the First World War, it put on shows for soldiers convalescing in Gateshead. By 1920 it was the cheapest cinema in the town, with seats costing only 2d and 3d, and it was the last cinema in Gateshead to be given a sound system. The unwary who sat in the front row never made the same mistake again as they usually ended up being sprayed by disinfectant, and patrons often found amusement in the silhouette of the rats as they ran behind the screen. The identity of Mr Lloyd has never been determined – no manager or owner ever had that name. The Empress finally closed in 1956 after being refused a licence due to poor fire precautions. The building was demolished in November 1964.

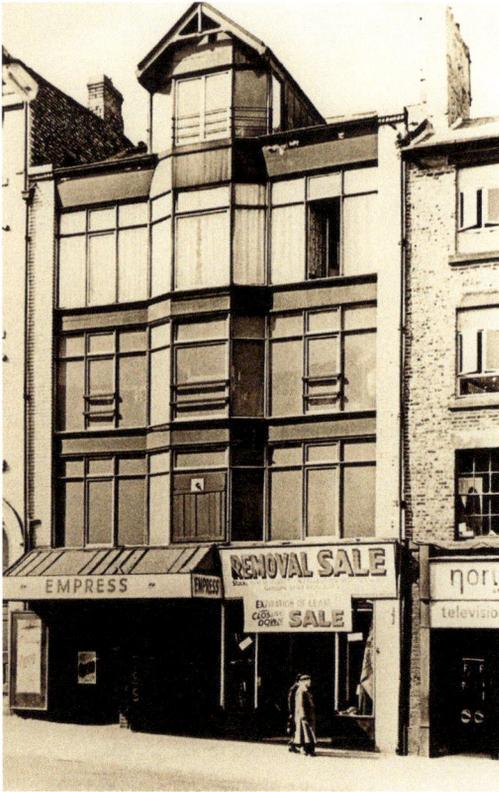

Empress Cinema, 1956.

Enchanted Parks

Part of the NewcastleGateshead Winter Festival, this very popular annual after-dark event takes place in Saltwell Park in Gateshead, which is transformed each year into a magical and mythical wonderland. Organised jointly by Gateshead Council and NewcastleGateshead Initiative, the event attracts thousands and has a new theme each year.

Enchanted Parks, *Intrude* by Parer Studios, 2017. (Courtesy of Richard Kenworthy)

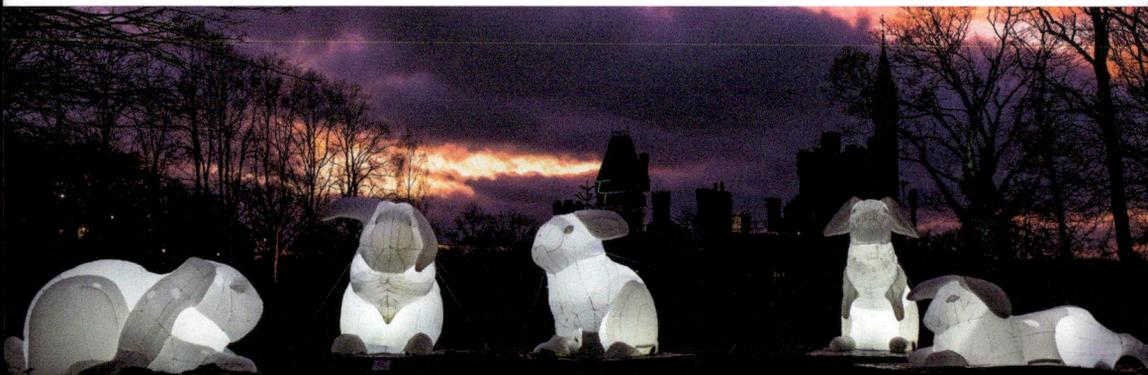

F

Field of Remembrance

In 2012, Saltwell Park hosted the Royal British Legion's first regional Field of Remembrance, and has continued to do so annually. The field honours the men and women of the region who have died in armed conflict, with thousands of wooden crosses bearing poppies and loving messages being placed each year in the Park. Saltwell Park is one of only six places in the UK to be chosen as a venue by the Royal British Legion.

Field of Remembrance, 3 November 2018.

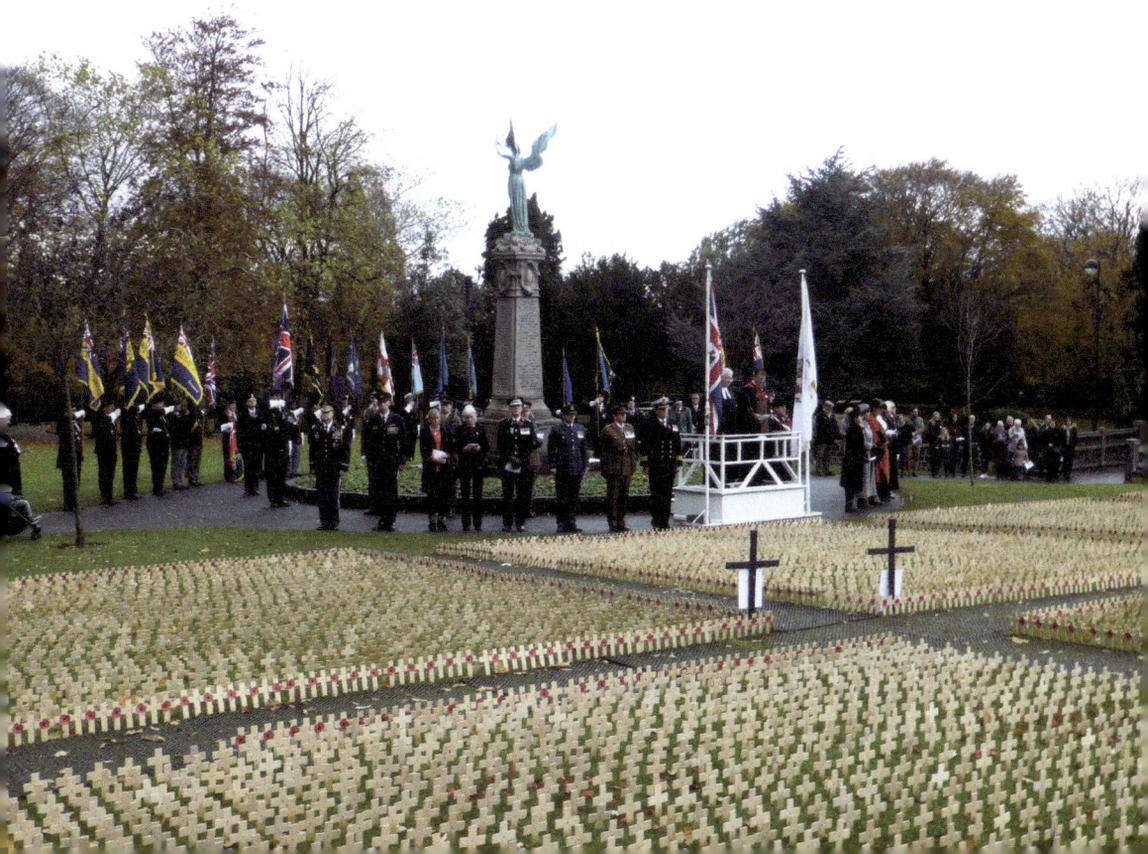

Friars Goose Pumping Engine

Gateshead had numerous pits, but many had short lives due mainly to flooding. In an attempt to combat this, Thomas Easton of Nest House on Felling Shore, designed a new pumping engine in 1822. The pumping engine, estimated to be around 180 hp, was owned by the Tyne Main Colliery, but a number of collieries contributed to the running of it, including Wallsend, Willington and Heaton on the other side of the River Tyne. Regarded as the most powerful pumping engine in the area, it was calculated in 1849 that it could draw off 1.5 million gallons of water per day.

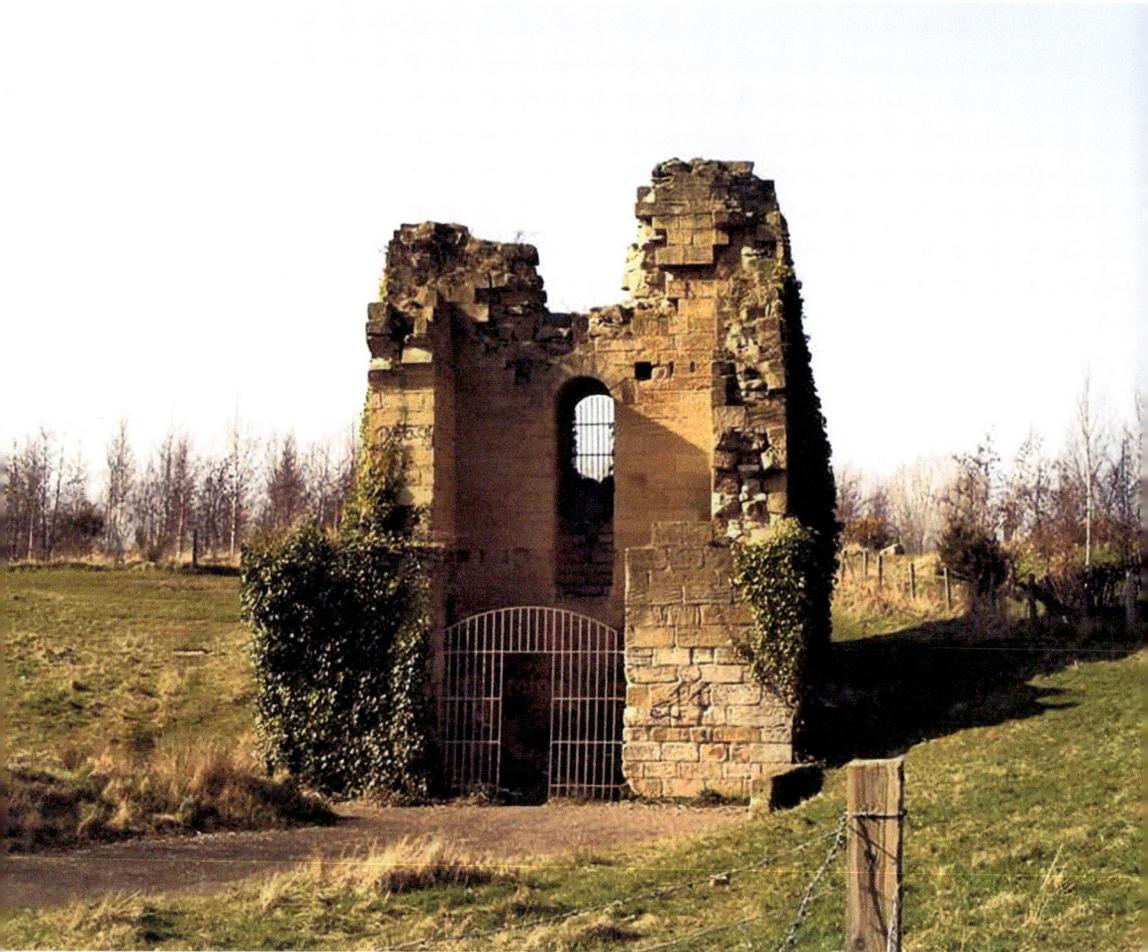

Friars Goose pumping engine.

G

Gateshead Garden Festival

Housed on a contaminated derelict site in the Teams area of Gateshead, the Gateshead Garden Festival, held in 1990, was the fourth of its kind to be held in Great Britain. Five were held in total – one every two years, each in a different location reclaiming large areas of derelict land. The festival site was created over a two-year period, on 200 acres of land, which had previously provided a home for a gasworks, a coal depot and a coking plant. The cost of reclaiming and redeveloping the land was around £37 million. The Staithes (possibly the largest wooden structure in Europe) provided a unique backdrop to the festival, although restoration was a formidable task. Gateshead's festival was held over 157 days between May and October 1990, and attracted over 3 million visitors. There were numerous displays of public art, a Ferris wheel and a space rocket. To help transport visitors, there was a monorail in the shape of a caterpillar (a butterfly was the logo of the festival), a narrow-gauge steam railway, and a ferry ran between Dunston Staithes and Newcastle quayside. Once the festival ended, part of the site was used for the new housing development of Festival Park.

Caterpillar monorail, Garden Festival, 1990.

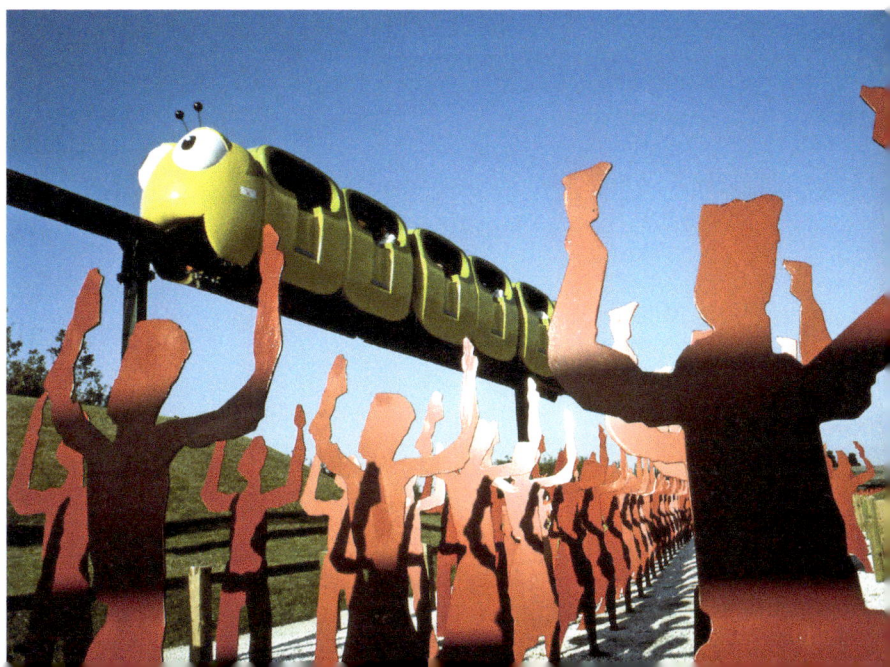

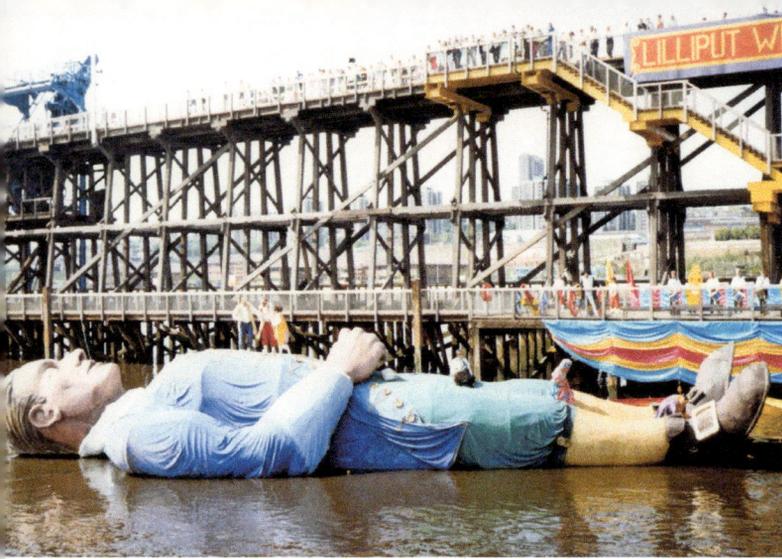

Gulliver figure, Garden Festival 1990.

Gateshead Millennium Bridge

This is the only tilting bridge in the world and was designed by Wilkinson Eyre Partnerships as part of a competition for a new bridge in 1996. It is a pedestrian and cycle bridge, which stretches 126 metres across the River Tyne. In a remarkable piece of engineering and with just 2 cms to spare, the bridge was lifted into place by the Asian Hercules II, Europe's largest floating crane, on 20 November 2000. It cost £22 million to build, partly funded by the Millennium Commission and European Regional Development Fund. The bridge opened to the public on 17 September 2001 with an official opening by the Queen on 7 May 2002. Nicknamed the 'Blinking Eye Bridge', the bridge takes less than five minutes to rotate and 36,000 people watched it tilt for the first time on 28 June 2001. Each time it tilts it cleans up its own litter. It has featured on a postage stamp and a £1 coin.

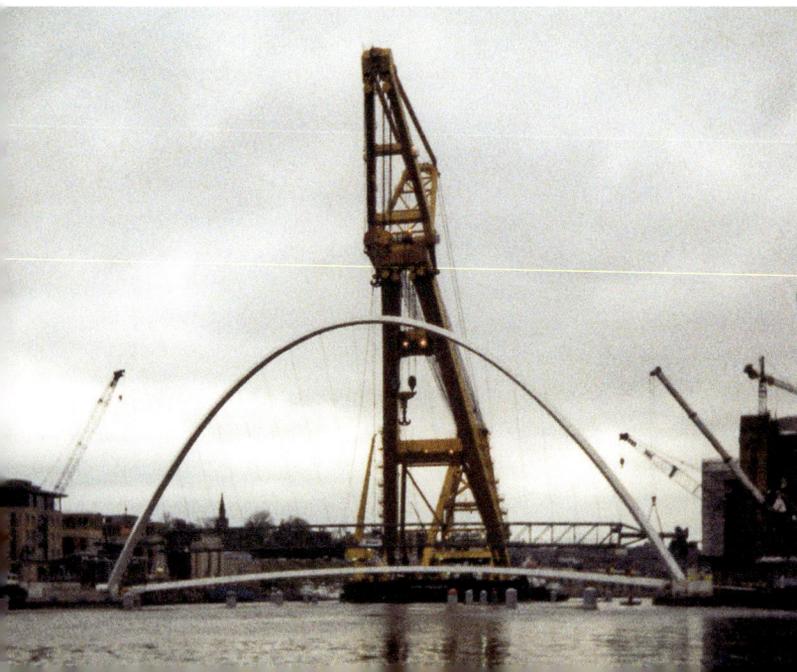

Gateshead Millennium Bridge with the Asian Hercules II crane.

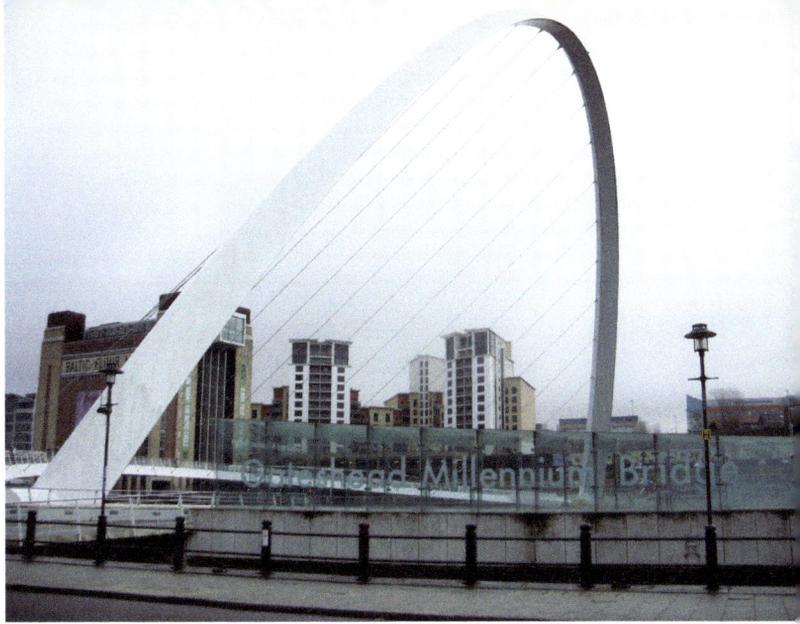

Gateshead
Millennium Bridge.

Glassworks

Glassmaking flourished during the nineteenth century and gave employment to many – not just those directly involved in the production, but also the hawkers who would sleep in the factories during the night so they could collect their glass wares first thing in the morning.

Glasshouses had been established by the mid-eighteenth century. Gateshead's South Shore housed Joseph Liddell's bottle house, and one early successful firm was that belonging to Joseph Price, who formed the Durham Glass Works in Pipewellgate around 1820. He concentrated on producing blown glass, especially globes for chandeliers, jars and tumblers. But Gateshead's two main glass-producing companies were those of Sowerby and Davidson.

Sowerby's, who had already been in existence for some years, began to produce pressed glass (the poor man's cut glass) from the 1850s onwards from their Ellison Works in East Street. In 1889, the firm formed a subsidiary 'fine art' firm – the Gateshead Stained Glass company. In the 1920s, they began to produce iridescent glass known as 'Carnival' glass. They were taken over by Suntex Safety Glass in 1957, and closed in 1972.

Davidson's glassworks in the Teams were Sowerby's main competitors. They were established in 1868 and, like Sowerby's, also produced pressed glass. Throughout the nineteenth and twentieth centuries they concentrated on tableware and produced many varied colours, styles and patterns. One of these was Pearline ware, which was clear glass at the base and opaque at the top. This proved popular and was frequently copied by other manufacturers.

In 1968 the works became known as the Brama Teams Glassworks, but the fuel crisis of the 1970s affected their furnaces and the firm eventually closed in 1987 after 120 years of glass production.

Above: Glassworks on Pipewellgate (site of glassworks in green), 1858 map.

Left: Dressing table set, Davidson's glass.

Great Fire of Gateshead

Shortly after midnight on 6 October 1854 a fire broke out in James Wilson's worsted factory on Gateshead's quayside, igniting some oil. The fire quickly spread next door to a free warehouse, once owned by Charles Bertram, which stored thousands of tons of sulphur and nitrate of soda, iron, lead, manganese, brimstone, guano, alum, arsenic, naptha and salt over six floors. It was potentially the largest lethal firecracker

on Tyneside! As the heat made the sulphur melt it streamed out of doors and windows, illuminating the surroundings in a beautiful purple glow. Crowds gathered on the bridges and along the quayside to watch the spectacle.

Fire engines came over to Gateshead from Newcastle to help and fifty soldiers of the 26th Regiment, led by Ensign Paynter, were dispatched from Fenham Barracks to help the firemen, and Charles Bertram was asked to attend due to his knowledge of the building.

A couple of small explosions went ignored. However, shortly after 3 a.m. a third explosion occurred, and it was this explosion that caused the damage. This was described in a contemporary newspaper report: 'The air was rent as by the voice of many thunders and filled as with the spume of a volcano.'

Vibrations were felt for 20 miles and the fire spread across the river to Newcastle. Gravestones outside St Mary's Church were broken and lifted, with stones as heavy as 6 hundredweight being hurled through the air for considerable distances. As all the fire engines were on the Gateshead side of the river, appeals for fire engines had to be telegraphed as far away as Berwick-upon-Tweed.

It took two days to extinguish the fires, and even then conditions were terrible for those trying to search for bodies. Bertram's former warehouse was completely destroyed and no trace of Mr Bertram was ever found – apart from his key and his snuffbox, which were found among the debris.

Of the fifty soldiers, thirty were killed. Another casualty was Alexander Dobson, son of the famous architect John Dobson, who was only identified by his pocket watch. The whole of Hillgate was destroyed and St Mary's Church was severely damaged. The final death toll was calculated at fifty-three people, with countless others suffering injuries.

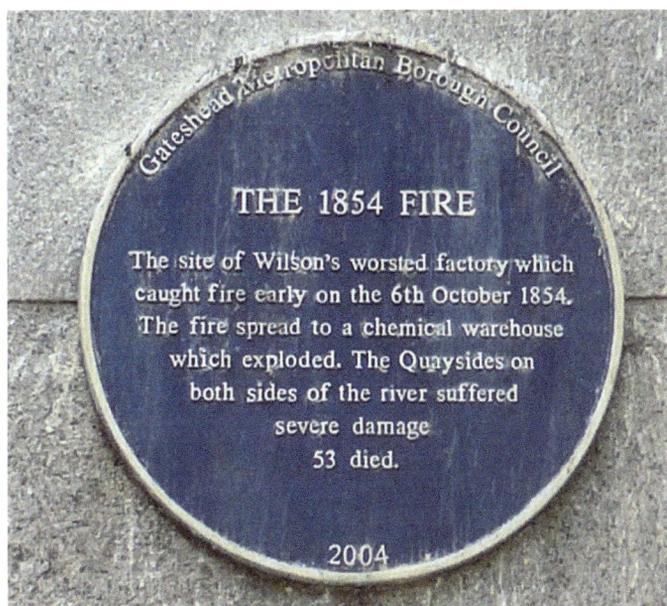

Blue plaque commemorating the Great Fire of 1854.

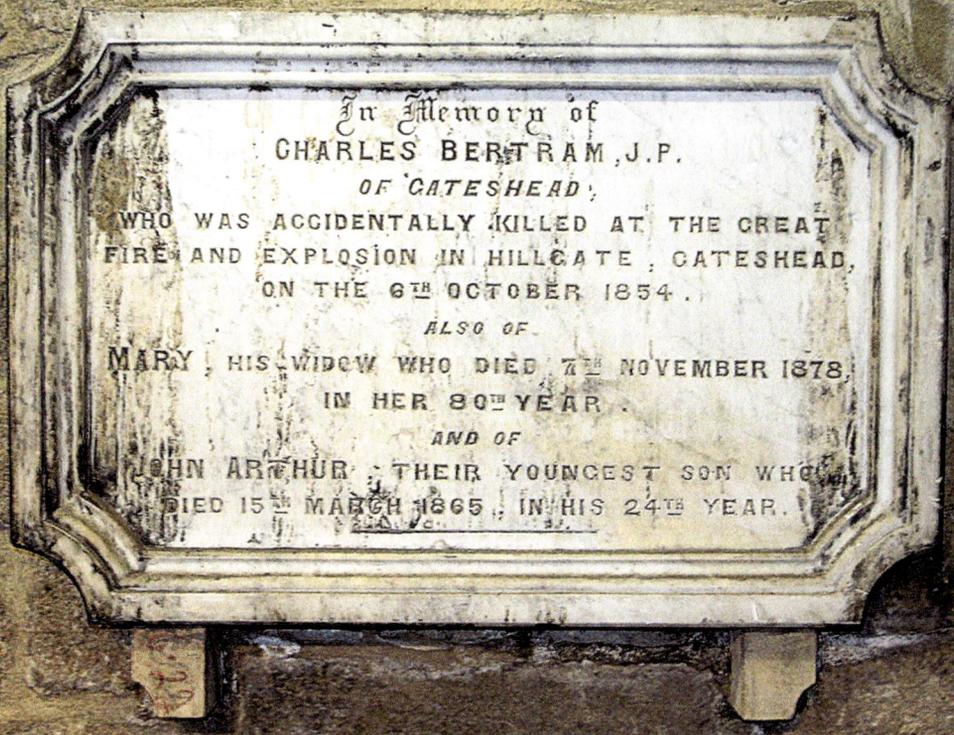

In Memory of
CHARLES BERTRAM, J.P.
OF GATESHEAD;
WHO WAS ACCIDENTALLY KILLED AT THE GREAT
FIRE AND EXPLOSION IN HILLGATE, GATESHEAD,
ON THE 6TH OCTOBER 1854.
ALSO OF
MARY, HIS WIDOW WHO DIED 7TH NOVEMBER 1878,
IN HER 80TH YEAR.
AND OF
JOHN ARTHUR, THEIR YOUNGEST SON WHO
DIED 15TH MARCH 1865, IN HIS 24TH YEAR.

Above: Memorial to Charles Bertram JP – one of the victims of the Great Fire.

Left: *Illustrated London News*, 14 October 1854.

Greenesfield Station

For many years this was the site of the North Eastern Railway works, but it started life as a passenger station. This was the first station, built as part of the Newcastle & Darlington Junction Railway, to be erected in either Newcastle or Gateshead that had not started out as a temporary structure. The station was built on Greene's Field on a high spot above the quayside.

The fact that the main station was in Gateshead and not Newcastle didn't go down well with people north of the river. The *Newcastle Journal* commented that perhaps at a later date it could be removed to the Newcastle side!

By mid-February 1844 the main contract for its construction had been given to Charles John Pearson, a leading Gateshead builder who promised completion within three months. Hawks Crawshay, the Gateshead iron founders, were casting the columns and the wrought-iron roof trusses for the train shed.

The first of these was raised into position by the end of April, and in another two weeks the shed was just about complete. After the platform and the tracks were laid, the opening took place on 18 June 1844 (just a month after Pearson's promised completion) amid much celebration. It was the very latest in station technology and design – the work of George Townsend Andrews of York, who had been the architect of the first station at York and a good friend of George Hudson, the 'Railway King'. It provided first- and second-class waiting rooms and a block at the east end of the station provided refreshment rooms and even bedrooms, so qualified as an hotel.

The station set a new standard in Gateshead's architecture and was regarded as a smaller-scale version of some of Richard Grainger's developments in Newcastle. The council moved their Town Hall into a house near the station site with high hopes that this would become their smart new civic area. Sadly, just six years later, with the opening of the High Level Bridge in 1849 and Newcastle Central station the following year, the station was redundant – completely bypassed by these new developments.

Greenesfield station (station building in green), 1858 map.

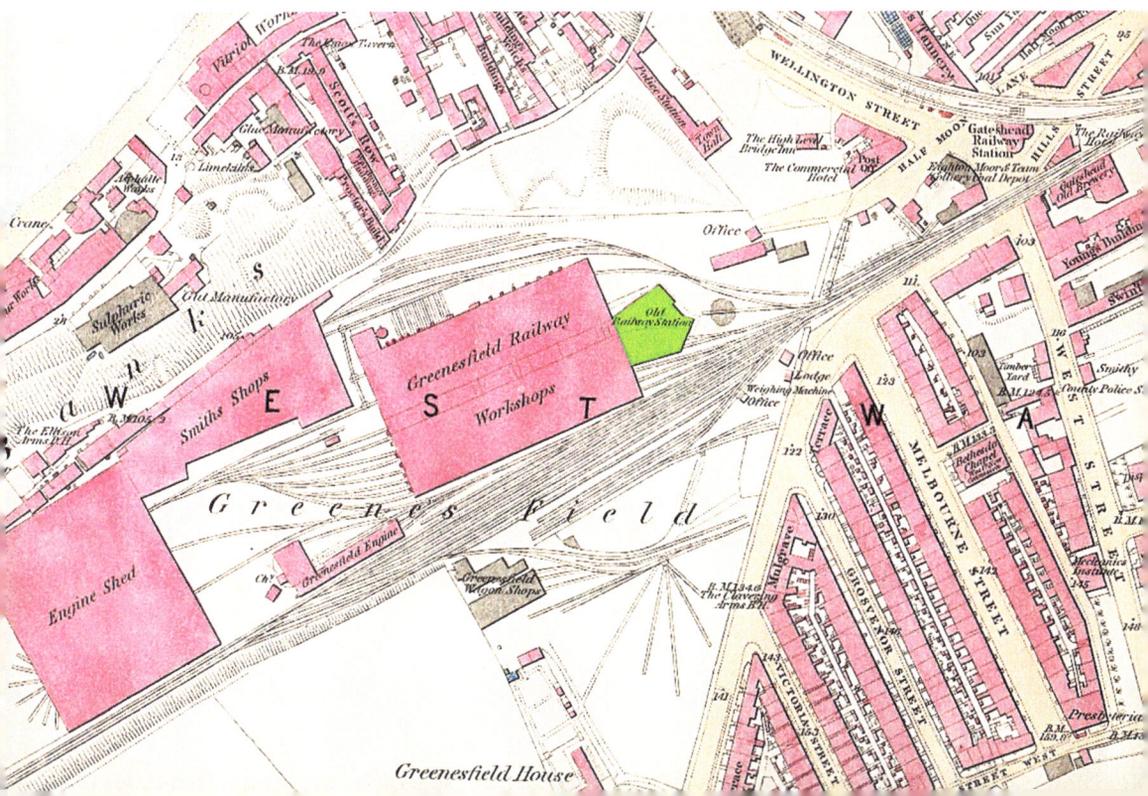

HMS *Calliope*

This shore-based training centre is situated on Gateshead Quays next to the Gateshead Millennium Bridge. The original training ship, built in 1879, was a corvette and was used as a reserve training ship on the Tyne from 1905 to 1951. This ship was later replaced by HMS *Falmouth*, which was re-christened *Calliope* (in Greek mythology, the muse of epic poetry) and berthed at Elswick. In 1968, the Tyne Division moved to its new headquarters at South Shore Road on Gateshead quayside. In 2016, Calliope benefitted from a major £3.1 million upgrade to become a major hub for Reserve Forces in the region. Renovations included a much improved exterior, new classrooms, office facilities and a state-of-the-art fitness suite. *Calliope* is now the principal Royal Naval Reserve training unit for the North East of England and is the home base for about 100 reservists.

Members take part in local representational activities and Remembrance Day parades in Gateshead and Newcastle. In 2008, HMS *Calliope* became an Honorary Freeman of the City of Newcastle.

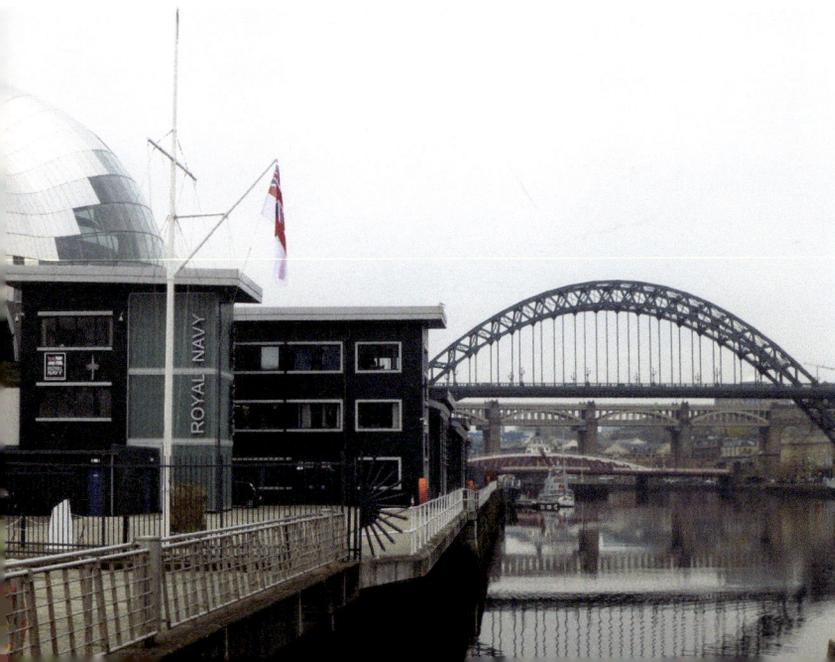

HMS *Calliope*.

Hawks, George (1801–63)

George Hawks was elected as Gateshead's first mayor on New Year's Day 1836, and was elected mayor twice more in 1848 and 1849. He inaugurated the annual civic service in November 1849 and two years later his wife together with 100 other ladies, presented the mayor's chain to the borough of Gateshead – the chain that has been worn ever since.

George was the great-grandson of William Hawks, who had established a small ironworks in Gateshead during the mid-eighteenth century. The company prospered and George became chairman of the company after the death of his uncle, Sir Robert Shaftoe Hawks. As a sign of his importance, when he was married in St Mary's Church on 10 November 1827, the church bells rang all day.

In 1849, the High Level Bridge opened (the first rail and road bridge in the world) and the Hawks Company provided the majority of the iron needed for construction. The task of hammering in the last rivet fell to George and, as mayor during that year, he was there at the formal opening by Queen Victoria – complete with a new set of mayoral robes purchased especially for the occasion.

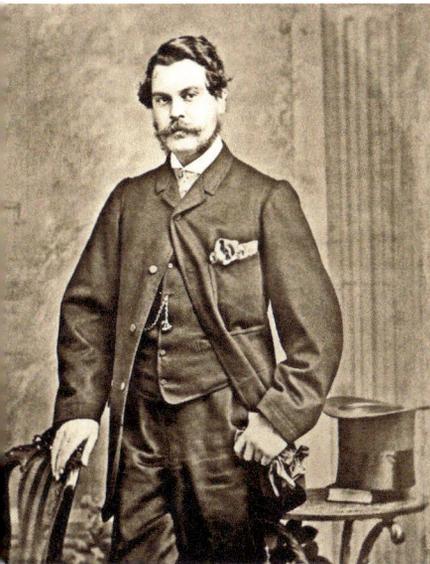

Above: George Hawks.

Right: George Hawks statue.

Regarded as a paternalistic employer, George built model cottages for his workforce near the Hawks ironworks. For a number of years, George lived at Redheugh Hall and despite the new railway cutting through his estate, still managed to keep his peacocks on the lawns. He died at his country house near Pigdon, Northumberland, but his body was brought back to Gateshead for burial in the family vault in the graveyard at St Cuthbert's Church in Bensham. Thousands attended his funeral. Two years later, the town's MP, William Hutt, unveiled a memorial to George on Windmill Hills in Gateshead.

Holmes, Arthur (1890–1965)

Born in Hebburn, Arthur Holmes lived for some of his early years in Primrose Hill, Low Fell, and attended Gateshead Secondary School. He studied physics at the Royal College of Science (now Imperial College) in London, but switched to geology in his second year. After graduating in 1910, he joined the staff of Imperial College. In 1913, he published *The Age of the Earth*, in which he argued that dating of rocks should be carried out by radioactive methods as opposed to methods that calculated the cooling of the earth. He continued to be a pioneer in this field for the rest of his life using new discoveries such as isotopes, and gained the nickname of 'Father of Modern Geochronology' (the dating of rocks, fossils and sediments).

Holmes was ahead of his time. Around 1930 he anticipated the theory of continental drift – thirty years before it was later expounded and proved. He came very close to describing the modern view of Earth's plates and the dynamics between them. Holmes established the Department of Geology at Durham University and was Professor of Geology there and at Edinburgh University until his death in 1965. He became a fellow of the Royal Society in 1942. As well as his earlier book, Holmes also wrote *Principles of Physical Geology*, which became a standard textbook.

Gateshead Council unveiled a blue plaque to commemorate Holmes's achievements at his former house on Primrose Hill in 2005, and a crater on Mars is named after him.

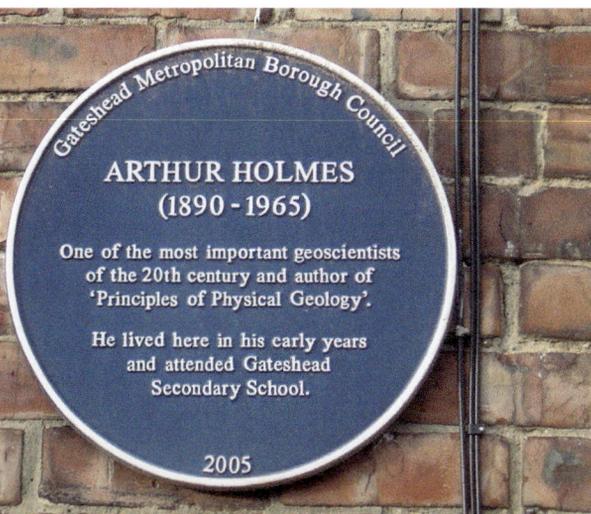

Blue plaque to Arthur Holmes.

Ingram, Blessed John

John Ingram was born in Herefordshire. While he was a student at Oxford he converted to Catholicism before studying abroad for the priesthood. On his return from Europe he began preaching in the Scottish Borders, but was eventually forced to flee to England. He was arrested while crossing the Tweed at Norham, near Berwick, and sent to Newcastle, then York and finally to the Tower of London where, despite being horrifically tortured, he refused to betray his friends and associates.

He was sent to Durham for trial where he was convicted and condemned to death along with two other Roman Catholic martyrs. On Friday 26 July 1594, John Ingram was hung, drawn and quartered on a gallows outside what is now St Edmund's Church on Gateshead High Street. His last words to the people who would watch him die were: 'I take God and His Holy Angels to the record that I die only for the Holy Catholic Faith and Religion, and do rejoice and thank God with all my heart that He made me worthy to testify my faith therein by the spending of my blood in this manner.'

Below left: Bronze bust commemorating the Blessed John Ingram.

Below right: St Edmund's Chapel, High Street.

A total of 18*d* was paid for 'bringing his quarters off the gibbets' and an additional 4*d* was paid for the pannier that carried his body. Ingram was only twenty-nine at the time of his death. For many years, a blue cross outside the church marked the spot where the gallows stood. He was beatified on 15 December 1929 by Pope Pius XI and each year an annual commemorative procession takes place with a walk from St Andrew's Church, Newcastle, to St Edmund's in Gateshead.

International Paints

In 1881, two German brothers, Max and Albert Holzapfel, along with Charles Petrie founded the Holzapfel Compositions Co. Ltd in Newcastle, specialising in the production of marine coatings for the local shipping industry. They called their paint brand 'International'. They soon needed larger premises and moved to Gateshead, and in 1904 moved to another larger factory further downriver in Felling. By this time it was a truly international company, producing paints in a number of other countries, including the USA and Russia. During the First World War it moved its headquarters to London and during the interwar period covered the globe, expanding into domestic and also industrial paints. It is now in over sixty countries, but the Felling site remains the largest with almost 1,000 employees.

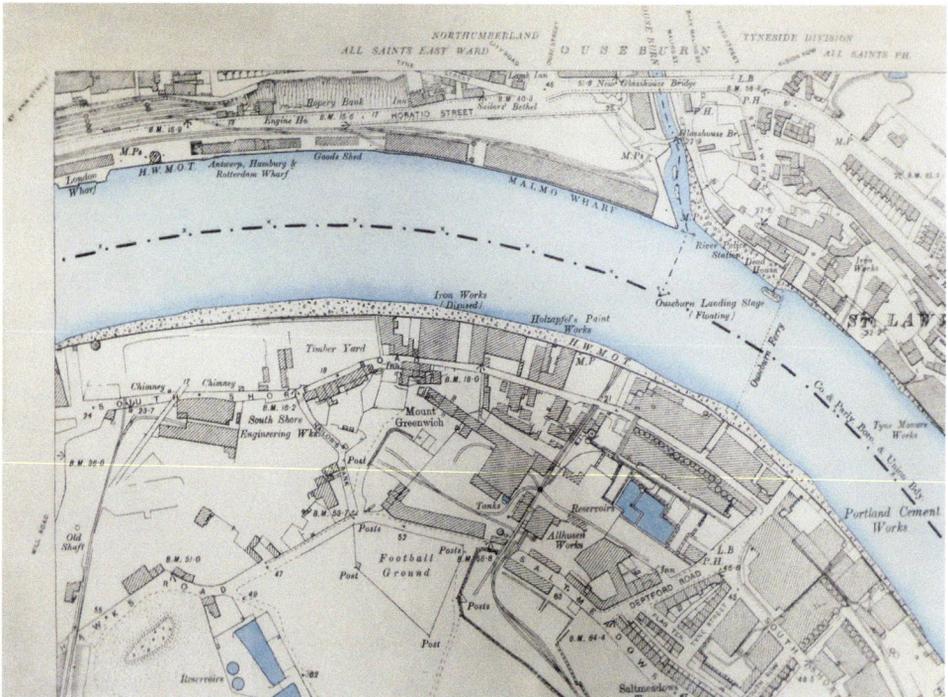

Site of International Paints, 1898 map.

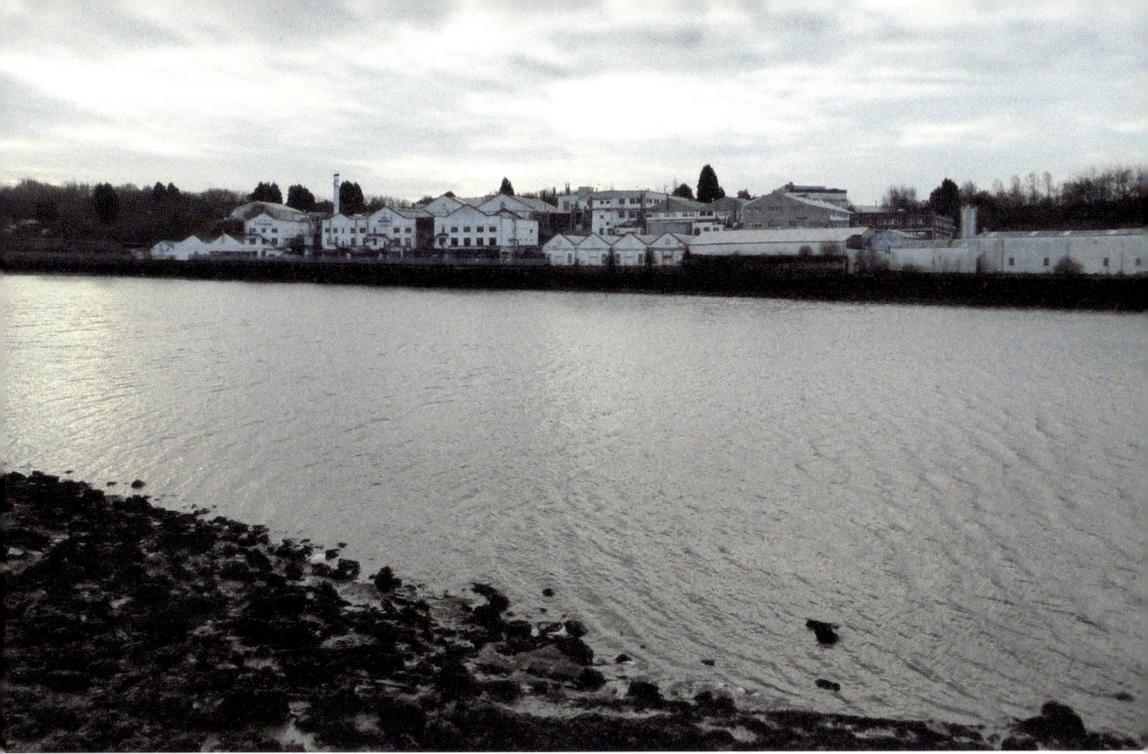

International Paints.

International Stadium

This was opened as Gateshead Youth Stadium by the former international athlete Jim Peters on 27 August 1955. The stadium was built on the site of a former chemical works spoil heap and the idea for its creation seems to have come from the then Mayor of Gateshead, J. T. Etherington, as an activity to combat youth crime. It cost £30,000. The original facilities were fairly basic – little more than an asphalt cycling track and a cinder running track – with a seating area and floodlights added later. When Brendan Foster discovered that a new synthetic running track was being planned for the stadium, he made a promise that if this was created, he would not only run at the stadium but break the world record in the process. This became the impetus

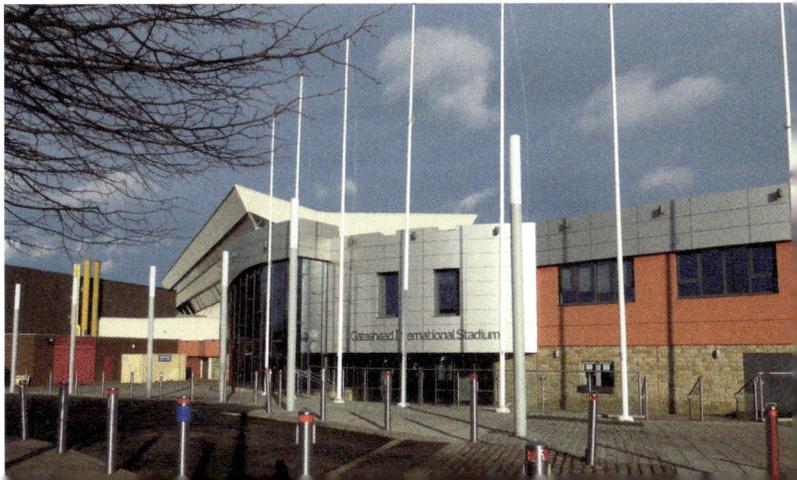

Gateshead International Stadium.

behind the first Gateshead Games, held in 1974, which effectively put the stadium on the athletics map with Foster breaking the 3,000 metres record on 3 August 1974 and provided it with its new name of Gateshead International Stadium. Further improvements have continued into the twenty-first century and the stadium now has a capacity of around 11,800. The stadium is the current home of Gateshead Football Club. When the club played Newcastle United in 1995, the crowd attendance was a record 11,750.

Ironworks

The best-known ironworks in Gateshead was that of Hawks, Crawshay & Sons, which was started by William Hawks in 1748 – Hawks had originally worked as a blacksmith at Ambrose Crowley's works at nearby Swalwell. Crowley's had their headquarters in Greenwich, London, and William named his new works New Greenwich in Gateshead. His son William took over in 1775 and greatly expanded the firm. They won government contracts for armaments, especially during the period of the Napoleonic Wars. The firm had warehouses in Deptford and Woolwich in London and established further premises in Gateshead, naming them New Deptford and New Woolwich.

By the end of the eighteenth century the firm had their own ships. Like the employees at Crowley's ironworks, those who worked for Hawks had various benefits, including houses and schools for their children, although working hours were very long with very little free time and poor wages. Children too worked long hours. In the nineteenth century the firm began to manufacture studded chain cables and expanded into building bridges and even lighthouses. They provided the bulk of the iron for the High Level Bridge, opened by Queen Victoria in September 1849. Other bridges were built as far away as India and Constantinople. This branching out into more and more products was ultimately the downfall of the firm, as other firms began to specialise in certain branches of the iron industry. The firm closed suddenly in 1889 although it was able to clear all its debts before doing so.

John Abbot & Co., who had begun manufacturing iron in 1825 near Oakwellgate, Gateshead, was the only company to rival Hawks in size. They moved into new premises – the Park Works – in 1835 and, like Hawks, manufactured a wide variety of items, producing among other things locomotive engines, hydraulic presses and safety lamps. However, as with Hawks, their lack of specialisation was their downfall, and the firm went into voluntary liquidation in 1909.

Ironworks on a smaller scale belonged to William Galloway, who had a factory at the end of Sunderland Road that he had founded in the 1850s. This factory made nails and employed around twenty-five to fifty people, including many women. The factory was moved to Blaydon in 1952 and was taken over by Guest, Keen and Nettlefolds in 1965.

J

Japanese Garden

In 1998, Gateshead created a typical English garden in Komatsu, the town they are twinned with in Japan. In 2008, following his Freedom of the Borough award, the mayor of Komatsu, Toru Nishimura, offered to provide a Japanese friendship garden in Saltwell Park to celebrate the strong links between the two towns. The resulting garden was designed by two Japanese garden designers, Hiro Kitamura and Susumu Kitayama, and includes traditional Japanese features such as a gravel pond and a waterfall, with the water represented by gravel. Japanese lanterns are also a feature of the garden.

Japanese Garden, Saltwell Park.

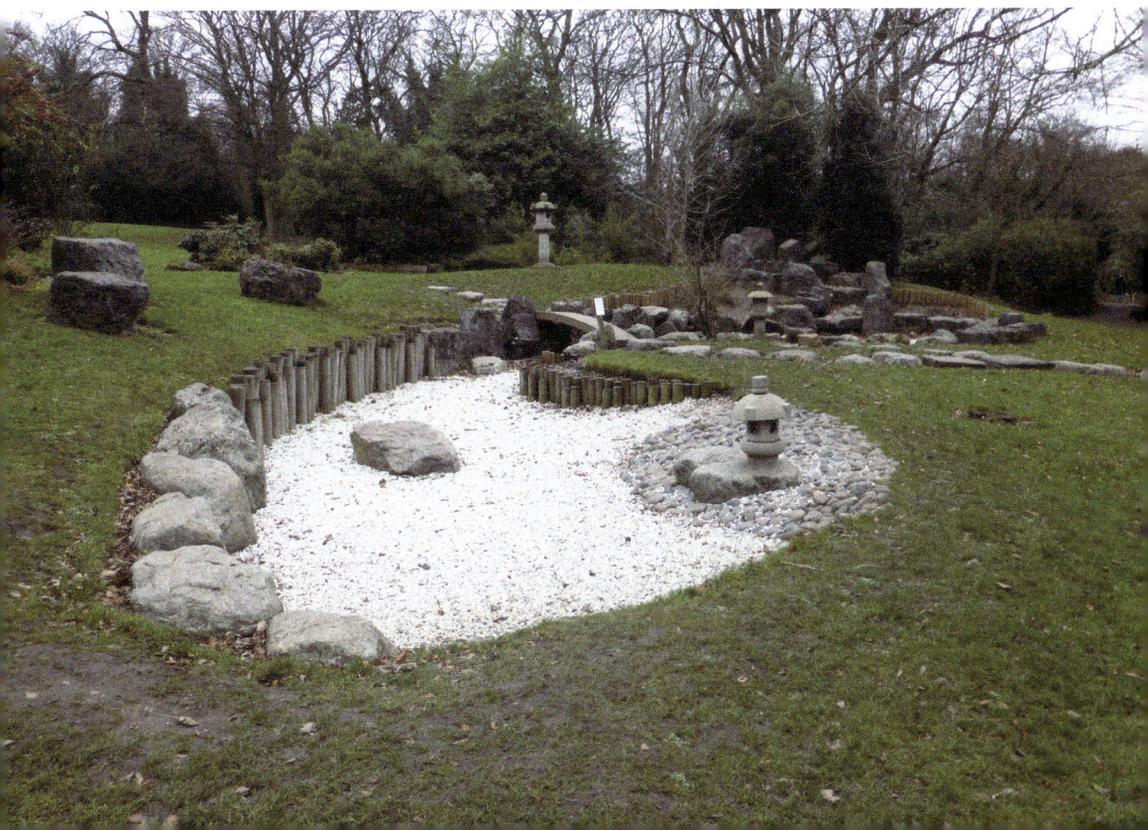

Johnson, Ronald Samuel (1949–98)

Sammy Johnson was born on 14 May 1949 on the Springwell estate in Gateshead. He learned to play guitar at an early age and played in a local band called Pigmeat. After playing bass guitar for a Live Theatre panto in Newcastle, he was offered a part in the show, and this was the beginning of his acting career. Sammy was best known for his role of Stick in the BBC series *Spender*, starring Jimmy Nail. He continued with his music career, however, and was a member of the Ray Stubbs R&B Allstars; he also formed Matt Vinyl and the Decorators. He began scriptwriting and moved to Malaga in Spain. This is where he died while training for the Great North Run. His early death shocked his many fans, and the Sammy Johnson Memorial Fund was set up. A variety concert, Sunday for Sammy, is performed every two years.

Joicey Family

The Joicey family were a well-known Gateshead family who owned extensive collieries in the West Durham coalfield. The founder of the firm, James Joicey, lived in Walker Terrace, Gateshead. Two of his sons, John and Edward, bought land to the west of Durham Road in Low Fell to build a fifty-roomed mansion – Whinney House – in 1864. The house, built in an Italianate style, was the largest of the mansions in the area, and their extensive land extended from Durham Road west to Saltwell Road. Not long after the house was built, John transferred his share of ownership to Edward.

Whinney House, Low Fell.

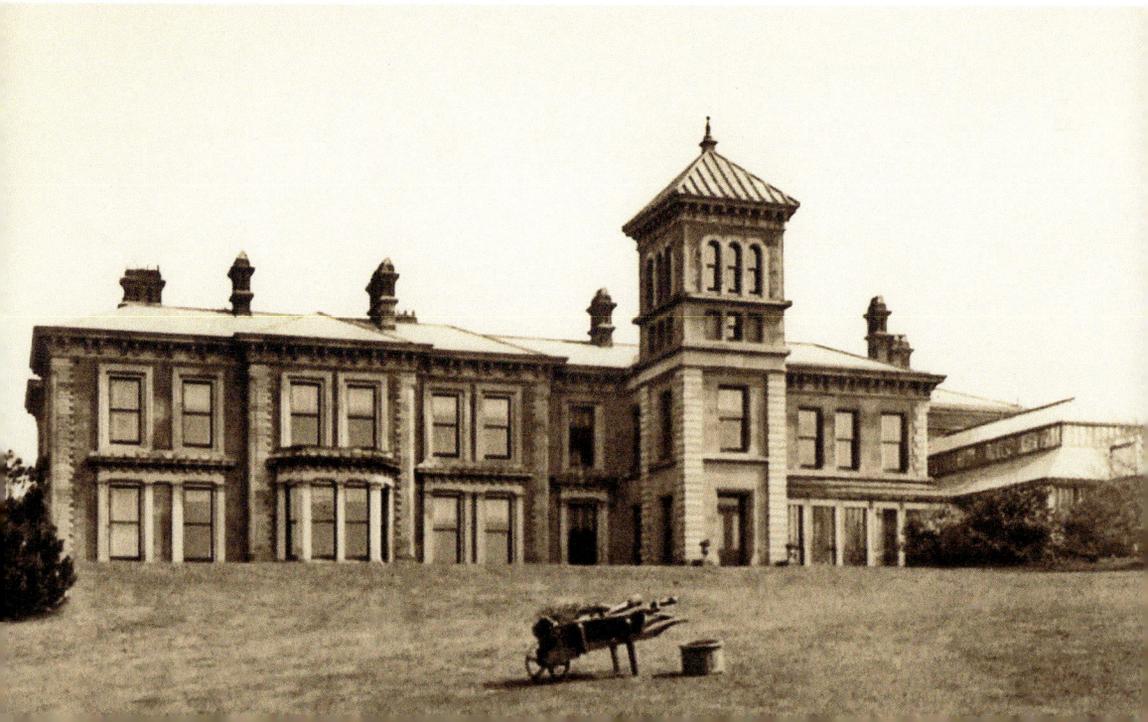

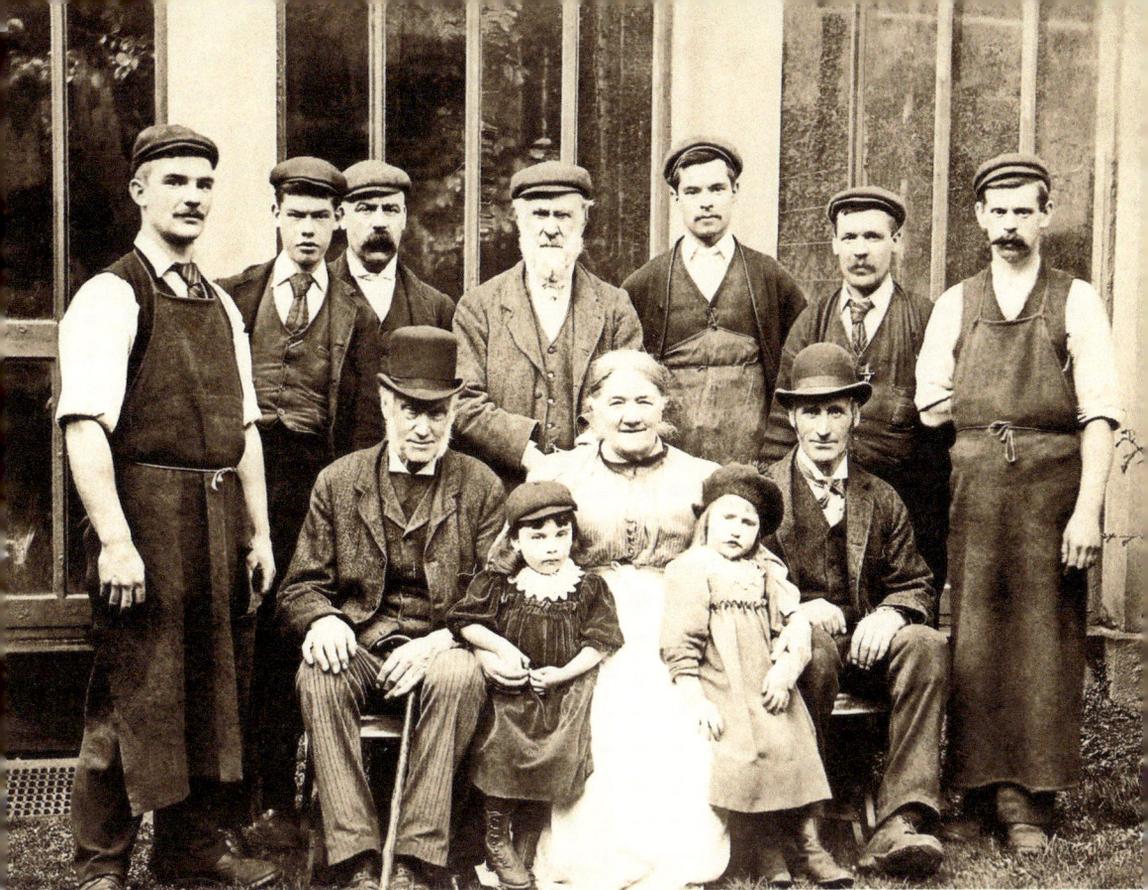

Gardening staff of the Joicey family, Whinney House.

There was a stone summerhouse and a large winter garden with some rare varieties of flowers and extensive glasshouses. The staff of nine gardeners specialised in growing grapes, peaches, bananas and pineapples.

After Edward Joicey, who had never had good health, died in 1879 his wife Eleanor Elizabeth continued to live in the house. When she died in 1906, the trustees of Edward Joicey retained ownership until 1913. In the years since, Whinney House has had a variety of occupants, and has been a Grade II listed building since 1983.

Their nephew, James, born in Tanfield in 1846 lived at Orchard House, Low Fell. He became MP for Chester-le-Street in 1885, holding the seat until 1906 when he was elevated to the peerage as Baron Joicey of Chester-le-Street. During his spell as Liberal MP he was created Baronet of Longhirst and Ulgham (two Northumberland villages). James had bought Longhirst Hall in 1887 and in 1907 bought the Ford Castle estate in north Northumberland. A year later he also bought the neighbouring Etal Castle estate. The Joicey family still own these today. James became a director of the London and North Eastern Railway on 4 March 1927. He resigned from this post on 7 March 1930 and died in February 1936.

K

King James Hospital

Formerly the Free Chapel of St Edmund the King and Martyr, the hospital was founded by Nicholas Farnham, who was bishop of Durham during the thirteenth century. In 1535, it owned 80 acres of land in Gateshead and Shotley Bridge, and received revenue from the coal deposits there. Since it wasn't dependent on a religious house, it survived the Dissolution and was refounded by James I as the Hospital of St James in 1611, with the instruction that the rector of Gateshead should be the master, that three ancient brethren should govern with him and that ten younger brethren should

St Edmund's Church, Old Durham Road, 1900.

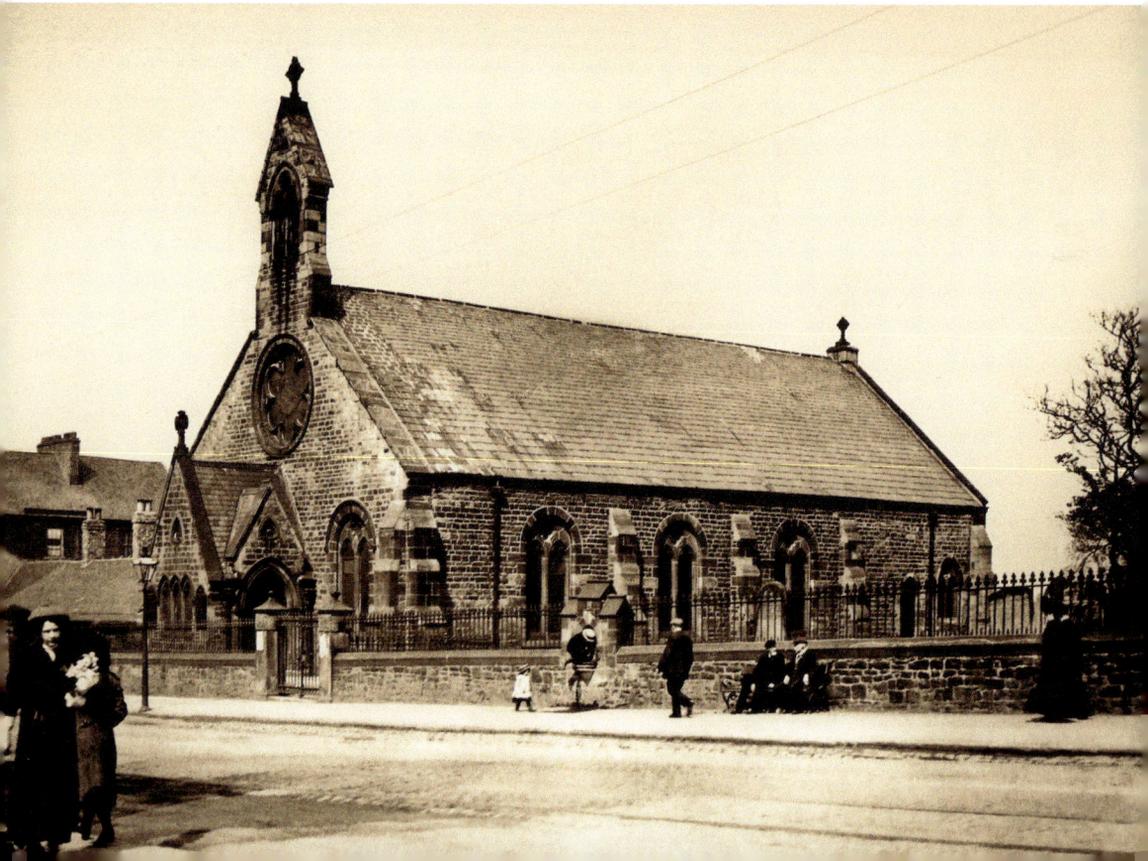

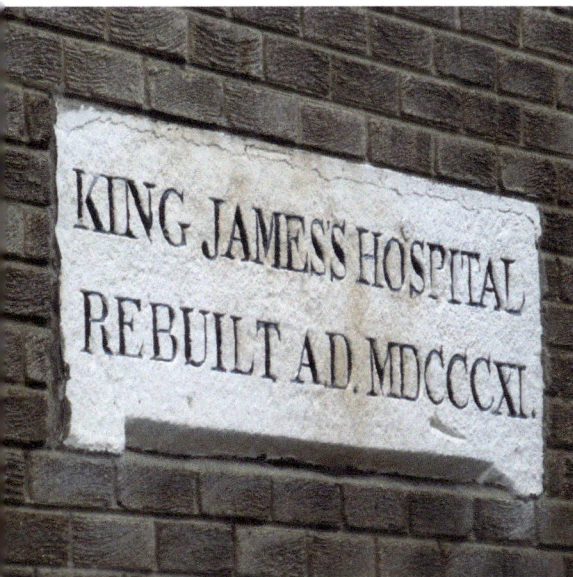

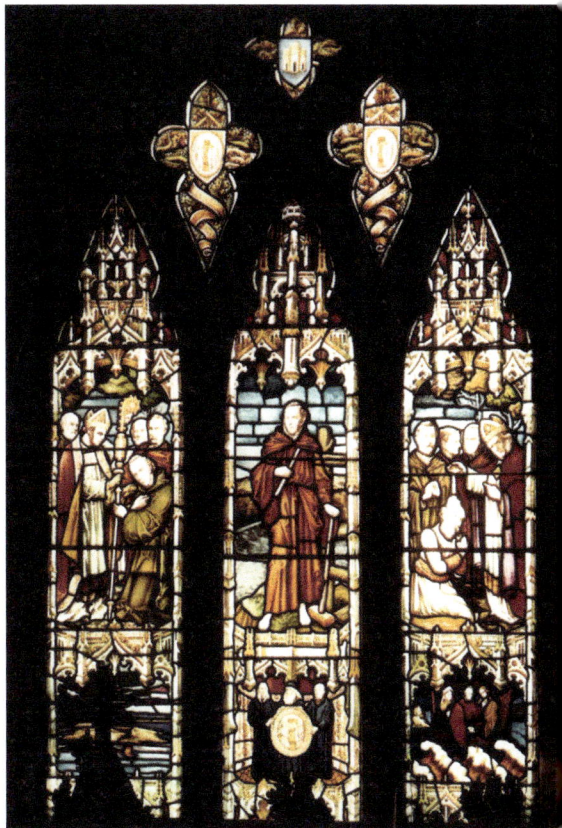

Above: King James Hospital plaque.

Right: King James Hospital window, St Mary's Church. (Courtesy of the Studio Low Fell)

benefit from the charity. They had to be of good character, single and over the age of fifty-six, and to have no more than £20 per annum income. The hospital chapel was used as a school on weekdays for the moral and religious instruction of poor children.

The chapel was rebuilt in 1810 as St Edmund's Chapel on Old Durham Road, with a cemetery being added the following year. This later became St Edmund's Church. The church was demolished in the 1970s and today a plaque on a house on Old Durham Road is all that remains. However, the almshouse charity is still in existence, catering for Gateshead residents of limited means. King James Street, eight Tyneside flats, were built in 1936 for the Masters and Brethren of King James Hospital, and more sheltered housing is available nearby.

Kittiwake Tower

Kittiwakes came to the Tyne to breed in the 1960s using old riverside buildings on Gateshead quayside – an unusual move as kittiwakes traditionally keep to the sea. By the 1990s, a nesting colony was in evidence at Baltic Flour Mill, but when the mill was being developed as an arts centre these kittiwakes were displaced and so a special

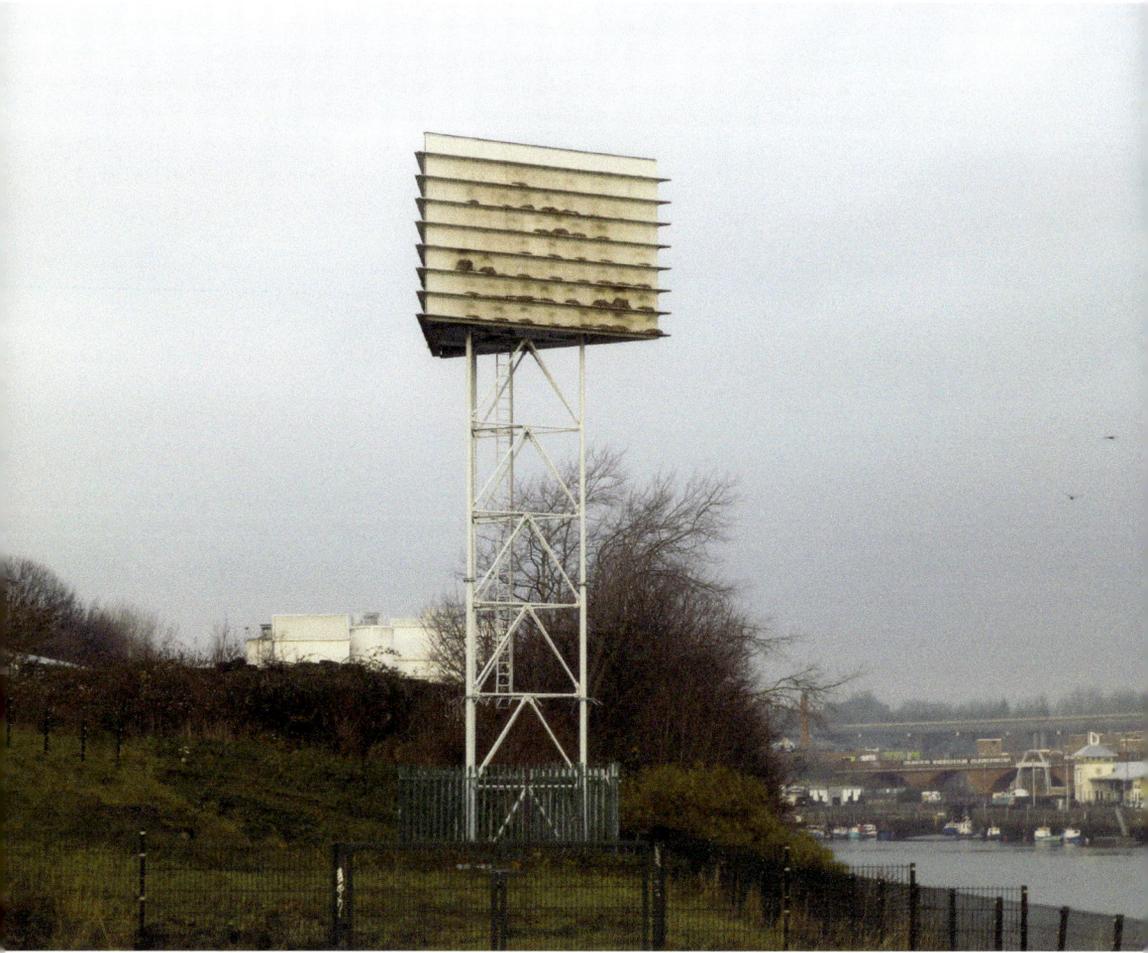

Kittiwake Tower.

kittiwake tower was built to house them in Baltic Square in 2001. Two years later it was moved to a new permanent home at Saltmeadows. Today around ninety pairs of kittiwakes use the tower usually between March and August. While they are nesting, the birds are legally protected. The rest of the year they spend out in the middle of the North Sea and North Atlantic.

L

Leathart, Constance (1903–93)

Constance (Connie) Ruth Leathart was born on 7 December 1903 in Low Fell, Gateshead. In 1925 she began flying lessons at Newcastle Aero Club, writing her name as 'C. R. Leathart' on the application form in order to disguise her gender. Despite crash landing on her first solo flight, the resilient Connie was soon back in the air and received her flying licence in 1927, becoming the first British female pilot outside London to achieve this. She took part in many air races and set up and ran Cramlington Aircraft with her lifelong friend Walter Leslie Runciman (later Viscount Runciman).

In 1939, while working in the map department at Bristol Airport she joined the Air Transport Auxiliary (ATA) and achieved the rank of flight captain (equivalent to squadron leader in the RAF). She flew a wide variety of planes, from Spitfires to heavy bombers, to airfields in many countries. After the war, she became a United Nations special representative to the Greek island of Icaria, receiving an award of merit from the International Union for Child Welfare. She retired from flying in 1958 and for the rest of her life cared for rescued donkeys on her farm in Little Bavington, Northumberland. She is buried at Thockrington Church, Northumberland.

Little Theatre

The Little Theatre is probably the only theatre in Britain to be opened during the Second World War, and its construction was largely due to the generosity of three sisters – Hope, Ruth and Sylvia Dodds. Ruth had been a member of the Independent Labour Party, who had acquired the Westfield Hall in Gateshead. A drama club, the Progressive Players, was formed and plays were staged, but as a theatre venue the hall, which was used for different functions, had its limitations as whenever a play was performed all the scenery had to be dismantled then re-erected the following night. In 1938, the Progressive Players received notice to quit the Westfield Hall but all was not lost as it was learnt that 'funds were available' to build a small theatre. The three sisters provided the money to buy a vacant site overlooking Saltwell Park together with No. 3 Saltwell View, the adjoining house.

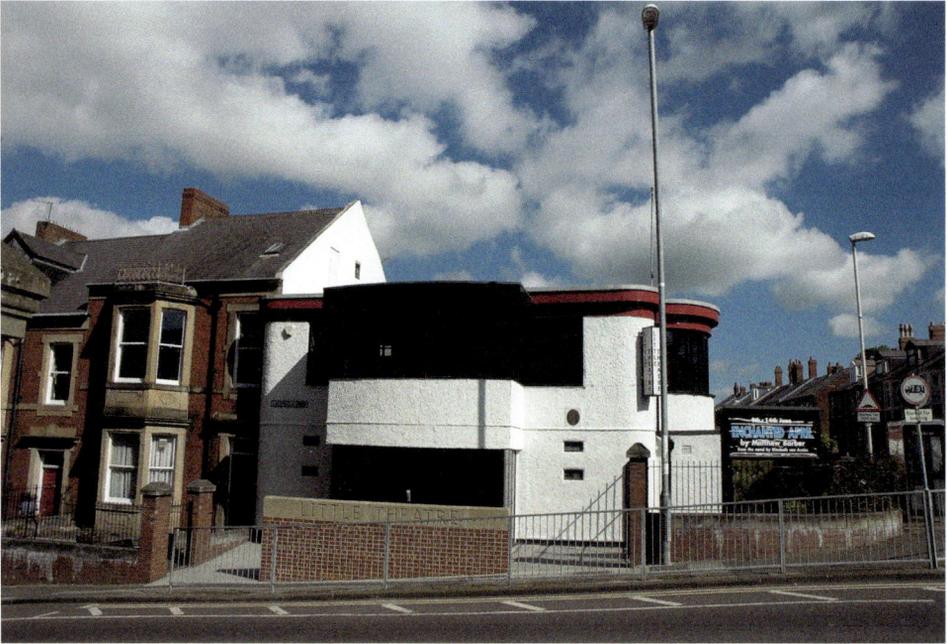

Above: Little Theatre, Saltwell View.

Left: Plaque to the Dodds sisters.

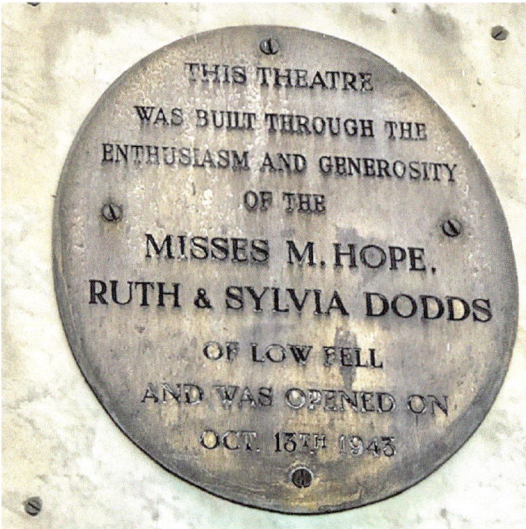

In 1943, building work was complete, but during an air raid a bomb fell in Saltwell Park just opposite the theatre. This had the effect of blowing in the windows and the doors and the trunk of a tree fell through the roof. Despite this setback, the theatre opened later that year with a performance of Shakespeare's *A Midsummer Night's Dream*. During the 1960s and 1970s there was a threat of demolition as a new road was planned that would have cut through the site. However, this never happened and so the theatre began to improve and expand, and in 1989 No. 4 Saltwell View was bought,

the upper floors of which now house the Progressive Players extensive wardrobe. Due to a generous legacy of a former member, there was considerable renovation and reconstruction of the frontage, foyer and bar in 2012–13. The Progressive Players perform two seasons of plays each year – each season containing five plays.

Lyndhurst Bowling Club

Cunningly concealed behind the wall of No. 735 Durham Road, Low Fell, is this bowling club. In 1904, Alderman William Clough and nine others purchased two plots of land to be used for recreation. The first plot was in Wrekenton, which opened in 1906 and became Ravensworth Golf Club, becoming independent of the bowling club in 1907. The second piece of land was in Low Fell, where three tennis courts were opened in 1905, and a bowling green, which opened in April 1906. This was for men only however until 1980 when a ladies section was formed with its own committee, beginning the start of mixed competitions.

While the bowling green is still used, the tennis club closed in 1967 due to falling membership. For a short period, the land was used as a market garden, and then in 1993 was sold to build single-storey bungalows.

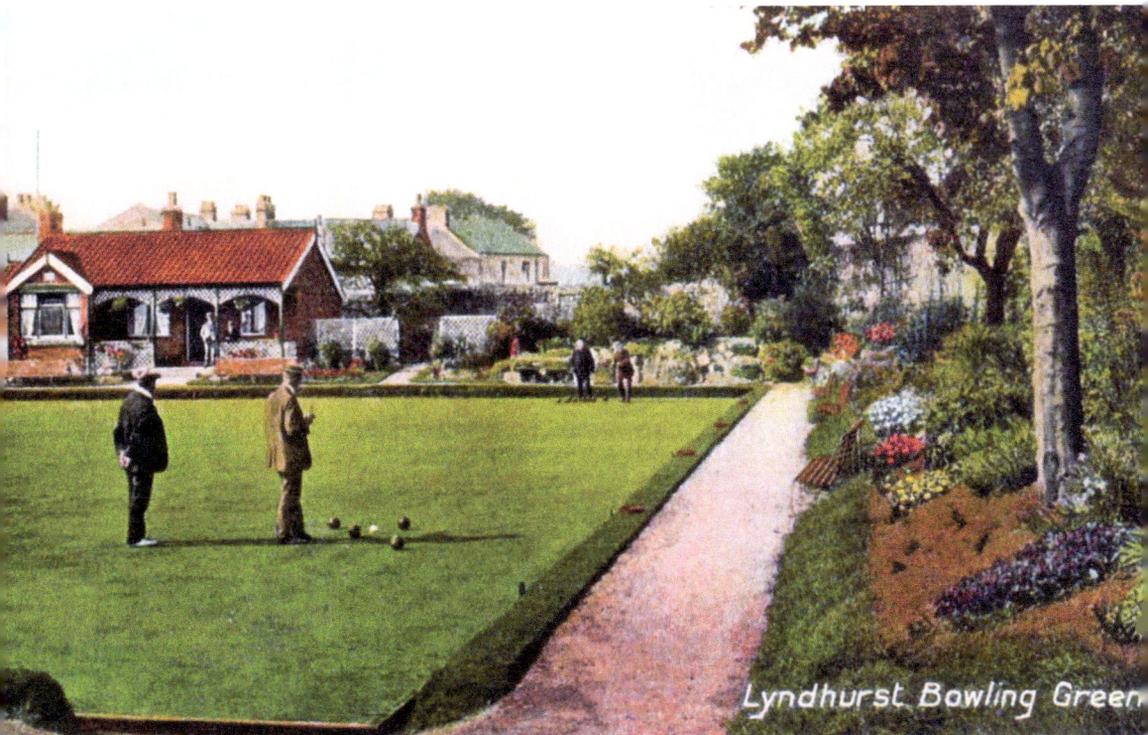

Lyndhurst bowling green, *c.* 1910.

M

Maccoy, Alderman Sir John (1840–1932)

Born in Bishop Auckland, John Maccoy was a wealthy shipowner, formerly superintendent of the Prince Line of steamers and was mayor of Gateshead on eight occasions between 1912 and 1923, and remains the only mayor to be knighted. He was granted the Freedom of the Borough in 1930 to celebrate his twenty-five years on the council. He lived for many years in Springfield House on Durham Road. Following the death of his wife Rebecca (the result of a car accident in 1914), he presented the town with a drinking fountain in her memory. This was originally situated in West Street, then in Ellison Street, but has now been moved to the area next to the former site of Gateshead East Station.

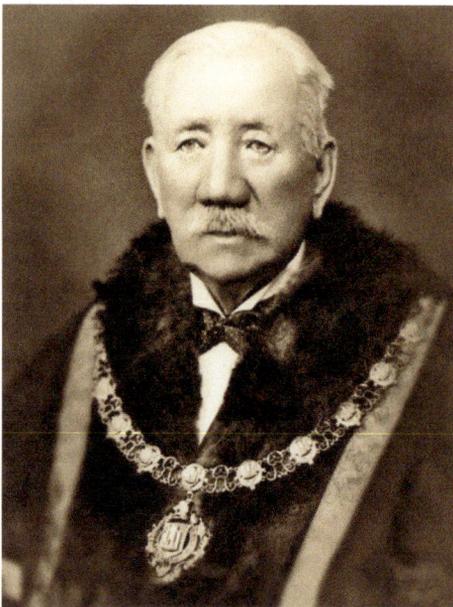

Above left: Sir John Maccoy, 1924. (Courtesy of Bainbridge Art Studio)

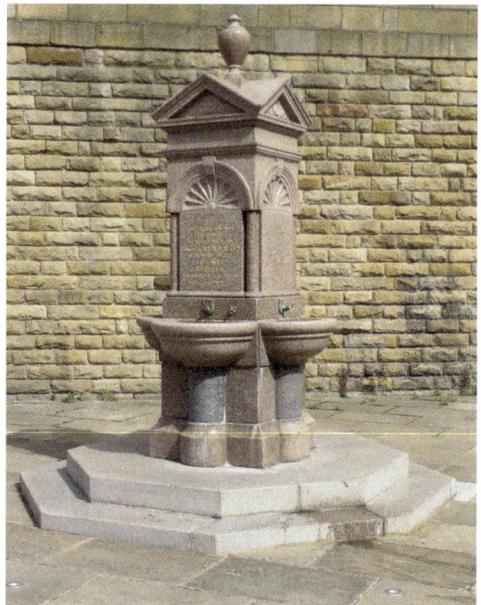

Above right: Memorial fountain to Rebecca Maccoy.

McMenemy, Lawrie (b. 1936)

Lawrence McMenemy MBE was born in Gateshead on 26 July 1936 and started to play football on the cobbled streets of the Avenues in the Bensham area of the town. He played football for Newcastle United and Gateshead, but his career was ended by injury in 1961. Moving into coaching, he was subsequently appointed manager of Bishop Auckland in 1964 and then managed Doncaster Rovers, Sheffield Wednesday, and Southampton. In his first year at Southampton he led the club, then in the Second Division, to victory in the FA Cup in 1976 where they beat Manchester United 1-0. After leaving Southampton in 1985, McMenemy became manager at Sunderland but left after two years at the club. Following a three-year break from football, McMenemy was appointed England's assistant manager. He resigned in 1993 and later took on the role of manager of Northern Ireland, leaving in 2000. Since then, he has been an FA special ambassador. He is rated in the Guinness Book of Records as one of the twenty most successful managers in post-war English football.

Maiden's Walk Coal Drops

These Grade II listed structures are located on the east side of the former Oakwellgate station and can be viewed from the upper Sage Gateshead car park. There are a total of fifteen piers built of local sandstone rubble, with dressed corner stones that were

Maiden's Walk coal drops.

built in two stages, with the eight southernmost drops having thinner piers than the remaining six to the north. The increase in thickness may have been due to the sloping of the ground towards the river and to allow for the additional weight of masonry in the highest piers. When the drops were in use, wagons were shunted along the top of them and halted above a hopper (a funnel) where the coal was discharged. Later, wagons would be tilted on their carriage or emptied through a trap in the floor. Three sloped surfaces funnelled all the coal down towards a hole leading to the discharge chute. Hinged gates could be opened to empty the coal into waiting tubs. The chute and hopper were supported on massive timber beams let into the pier walls on either side. The inner surfaces of the hopper and delivery chute were lined with iron to ease the flow of coal, which might otherwise have become 'snagged' on the timberwork. The coal drops as they exist today have been altered from their original layout, and the viaduct to the south, which moved wagons along the length of the drops, is a later addition. By 1844 coal was being transferred from the drops to a cinder works and later the South Shore coke ovens. The drops also handled lime from a limekiln at the foot of the incline as well as supplying the nearby Park ironworks with coal.

Mechanics' Institute

On 13 November 1836, a public meeting was held at the Town Hall to discuss the possibility of beginning a Mechanics' Institute. Within a year there were 236 members and early meetings were held in various buildings, including the Town Hall, the Bethesda Chapel and the Grey Horse. By 1839, however, enthusiasm was waning and the committee noted with regret that it was used by every class of society except those

Mechanics' Institute, West Street.

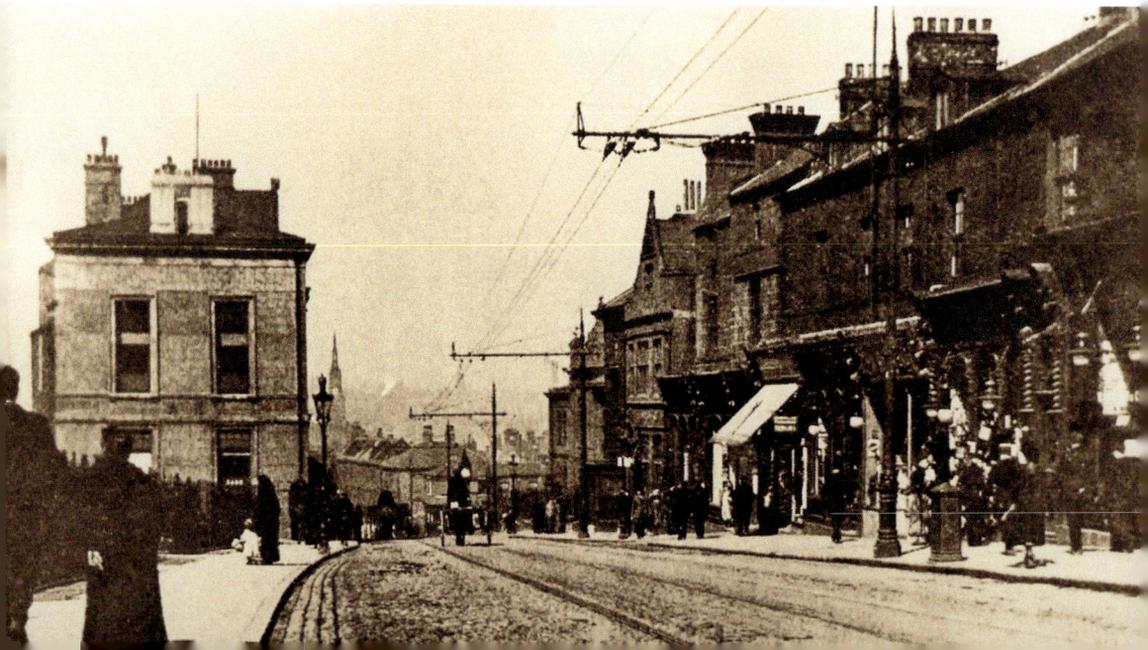

for whom it was formed. Despite this – or perhaps because of it – it was decided to erect a permanent building, and this opened on West Street in 1848. However, by the turn of the century it had become little more than a social club and was sold to the council in 1907, then converted into a bank. It was finally demolished in 1971.

Metrocentre

In 1984, Gateshead Metropolitan Borough Council and local businessman Sir John Hall launched their proposed out-of-town development of a shopping and leisure centre on a power station's waterlogged ash dump. The Metrocentre opened in stages, with the first phase opening on 28 April 1986 – the red mall that featured a large Carrefour supermarket. This later became Gateway and subsequently Asda. The Metrocentre also featured the first out-of-town Marks & Spencer. The official opening was on 14 October 1986.

Over a period of thirty years, the Metrocentre has seen many changes with various refurbishment programmes. Today, there are five main malls – Red, Green, Blue, Yellow and Platinum – together with themed shopping areas: The Village (originally the Antiques Village), The Forum (originally the Roman Forum), and Qube (originally the Mediterranean Village and an amusement area, 'Metroland'), which is now the cinema complex and houses over fifty restaurants and cafés. The former central area of the centre has been refurbished and renamed the Platinum Mall. The Red Mall was completely revamped with a new car park and Debenhams store.

In addition, a new Public Transport Interchange at the end of the Blue Mall now provides improved bus links to many parts of North East England and accommodates coach services from all over the UK. The Metrocentre railway station is now part of the Newcastle–Carlisle railway.

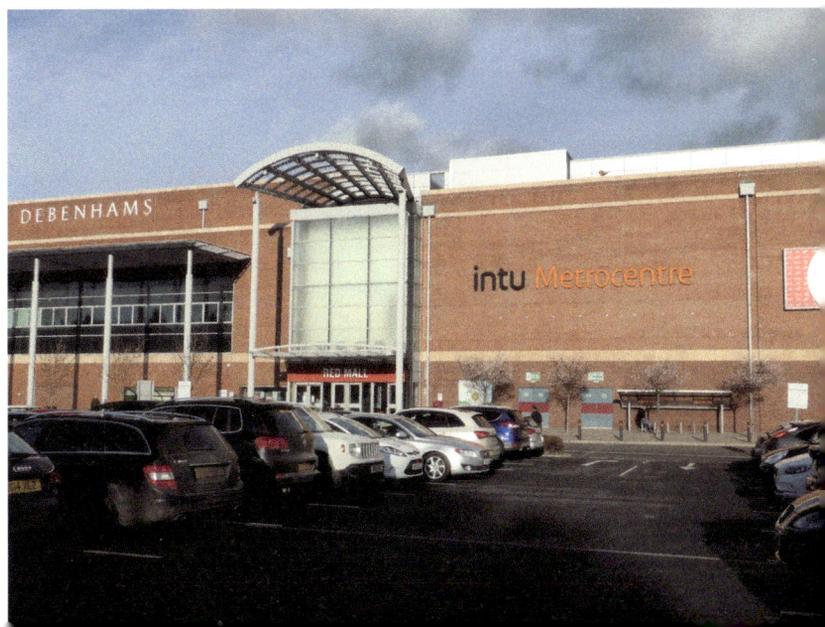

Metrocentre.

Norwood Coke Works

The plant, owned by the Teams By-Product & Coke Co. Ltd, started work in 1912 on the edge of today's Team Valley Trading Estate. A total of 250,000 tons of coke was produced each year, as well as by-products such as benzole, sulphate of ammonia and gas. There was also a tar distillery, which produced a range of products. The works were connected to various collieries over the years, but by 1930 most of the coal came from the nearby Watergate Colliery. The plant was nationalised in 1947 and the original ovens replaced to enable increased capacity. After Watergate Colliery closed in 1964 various other collieries supplied the coal. Following a declining demand for foundry coke, the coke ovens were closed in May 1980 although the site was used to stockpile coke from other areas until 1984. The tar distillery continued until 1986 using tar from other plants. The site later became part of Gateshead's Garden Festival in 1990.

Norwood coke works, 1977.

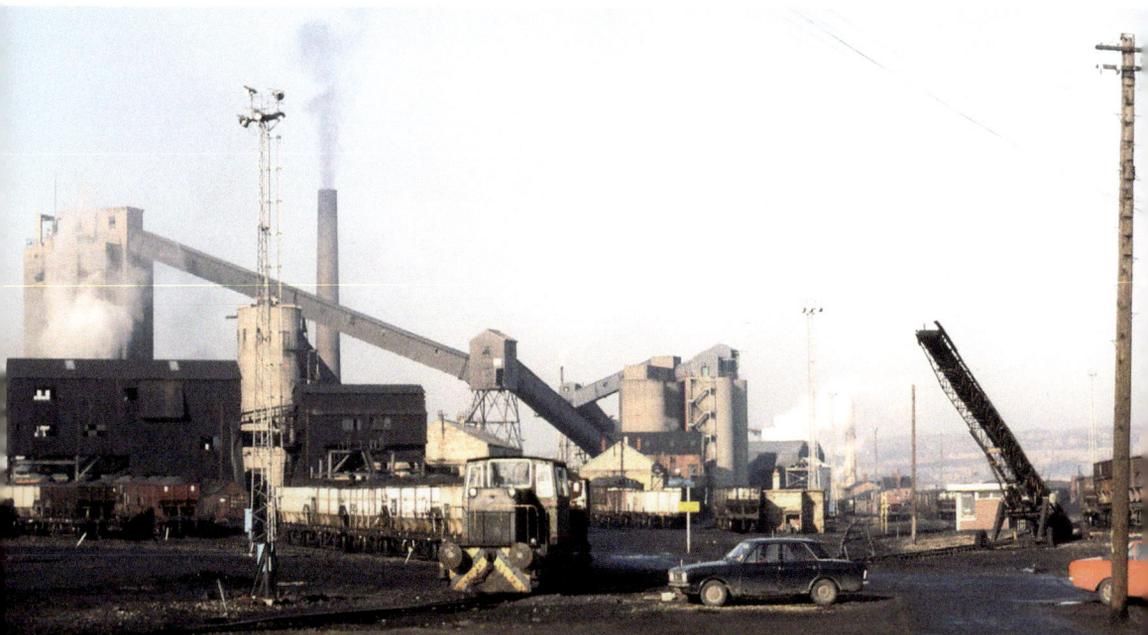

Nursery Gardens

Perhaps one of Gateshead's best kept secrets is that during most of the eighteenth and early nineteenth centuries, the town was a major area for market gardens. This was partly due to the importance of neighbouring Newcastle as a port, which meant

Nursery gardens, Cramer Dykes, 1858 map.

14 FRUIT TREES.

THE KINDS OF FRUIT TREES.

APPLES.

Keswick white Codling
Carlisle Codling
Kentish Codling
Manx Codling
Spring Grove Codling
White Hawthorndean
Cockpit
Flowery Town
Sir Walter Blackett's favourite
Nonsuch
Hutton's Nonsuch
Golden Pippin
Knight's Golden Pippin
Hughes's Golden Pippin
Cluster Golden Pippin
Ribston Pippin
Holland Pippin
Kentish Pippin
Lemon Pippin
Gateshead Lemon Pippin
Aromatic Pippin
Newtown Pippin
Whorl Pippin, or Strawberry
Orange Pippin
Kirton Pippin
Paradise Pippin
Prussian Pippin
Greenup's Pippin
Smith's Pippin
Gloucester Pippin
Syke House Pippin
Clermont Pippin, or French Crab
Balgown Pippin
Cockle Pippin
Summer Pippin
Tiffin's Pippin
Revelstone Pippin
Early Pine Apple Pippin
Woolaton Pippin

Munche's Pippin
Styford Pippin
Crofton Pippin
Kerry Pippin
Downton Pippin
Wormsley Pippin
Brongwood Pippin
Red Ingestrie Pippin
Yellow Ingestrie Pippin
Foxley Pippin
Silver Pippin
Padley's Pippin
Whyken Pippin
Court of Wick Pippin
Scarlet Pippin
Robinson's Pippin
Wood's New Transparent Pippin
Woodland Pippin
Nonpareil
Stagg's Nonpareil
Scarlet Nonpareil
Teesdale's Nonpareil
M'Donald's Golden Nonpareil
Golden Rennet
Monstrous Rennet
Frank's Rennet
Summer Pearmain
Winter Pearmain
Herefordshire Pearmain
Golden Russet, or Russetine
Royal Russet
Pile's Russet
Wheeler's Russet
Acklam Russet
Summer Redstreak, or Margaret
Winter Redstreak
Parkinson's Redstreak
Green Leadington

FRUIT TREES. 15

Grey Leadington
Scarlet Leadington
White Leadington
Red Calville
White Calville
Goodchild's Baker
Barnard's Baker
Gray's Spice
Lutwidge's Spice
Hutton's Square
Lemon Square
Yorkshire Green
Yorkshire Robin
Juneating
Margill
Ten Shillings
Worcester Forty Shillings
Kentish Fillbasket
Rambour
Cat's Head
Norfolk Beaufin
John Apple
Fullwood
Hunt House
Quince Apple
Wine Apple
Transparent, or Muscovite
Courpendu Rouge
Minchal Apple
Queen of England
Longstart
Almond Apple
Pomme Roi
Nunwich Red
Heburn Red
Original

Coulthard's
Cornish Crab
Partridge, or Peach
Jackson's or Middleton Hermitage
American Summering
Summer Queening
Caldwell
Bess Pool
Northern Greening
Eve's Apple
Arabian
Quarrenden, or Sack
Siberian Harvey
Golden Harvey
Grange
Loan's Keeper
Warburton's
Irish Pitcher
Pomme d'Api
Pomme Water
Kildare Seedling
Sack and Sugar
Drudge's Beauty of Wilts
Emperor Alexander
Lord Nelson's
Old Siberian Crab
Scarlet ditto ditto
Yellow ditto ditto
Striped ditto ditto
Striped leaved ditto
Evergreen ditto
North's Transparent ditto
Yellow Tartarian ditto
Sweet scented ditto
Double flowering Chinese ditto

PEARS.

Jargonelle
Dunn's Jargonelle
Crawford
Green Chissell
Hasell
Citron des Carmes
Early Catherine
Summer Portugal

Longueville
Gros Russellet
Swan's Egg
Moorfowl Egg
Drummond
Green Pair of Yair
Anchen
Golden Knap

Page from William Falla's fruit tree catalogue, early 1800s.

that Gateshead nurseries were able to easily distribute plants to Northumberland, Durham and North Yorkshire where previously plants had come from the great London nurseries. There were a number of market gardens and nurseries including those of James Leonard, who had market gardens on Gateshead High Street, but the main market garden family was the Fallas who transformed nursery gardening in the north over a period of sixty years.

William Falla took a lease from Henry Ellison in 1782 of a house, stables and two nurseries at nearby Hebburn for twenty-one years at £46 a year. Shortly after this, his eldest son, also called William, joined him in the business. The younger William lived at Cramer Dykes House on land that his father had bought a three-quarter interest in for £1,200 in 1799.

After the first William's death in 1804, the firm became known as William Falla & Co. and it stayed that way until 1840. It was during William Falla II's time that the nursery

became the largest in Britain. We know from his letters that he was an advocate of new machinery, and he became known as 'the Spade Husbandman'. One of his major achievements was to be given the contract by the Crown for the planting of Chopwell Woods. Shortly before 1816, he bought part of the Felling Hall estate and this may have provided a large area for his tree nurseries.

In 1823, he planted the trees around Heworth Churchyard and the following year leased around 26 acres to the east of Gateshead High Street from Cuthbert Ellison. In 1826, he was rated as having 63 acres of land, 8 acres of grassland, six greenhouses, and a house, coach house, granary, stable, four sheds, a two-stalled byre and a further dwelling house with front shop and a warehouse. By the time he died in 1830, his nurseries covered over 130 acres and were considered the most extensive concern of the kind in England.

William's son, also called William, was also a noted plantsman, but unfortunately not a great businessman, preferring to collect plants rather than sell them. Eventually, beset by money troubles, he disappeared in April 1836 and was later found to have committed suicide in Ravensworth Woods near Lamesley. The nurseries were then taken over by his creditors, until eventually they were reconstructed and continued by Charles I'Anson and Samuel Finney, trading as I'Anson and Finney, then finally trading as Finneys Seeds.

O

Oakwellgate Baths and Washhouses

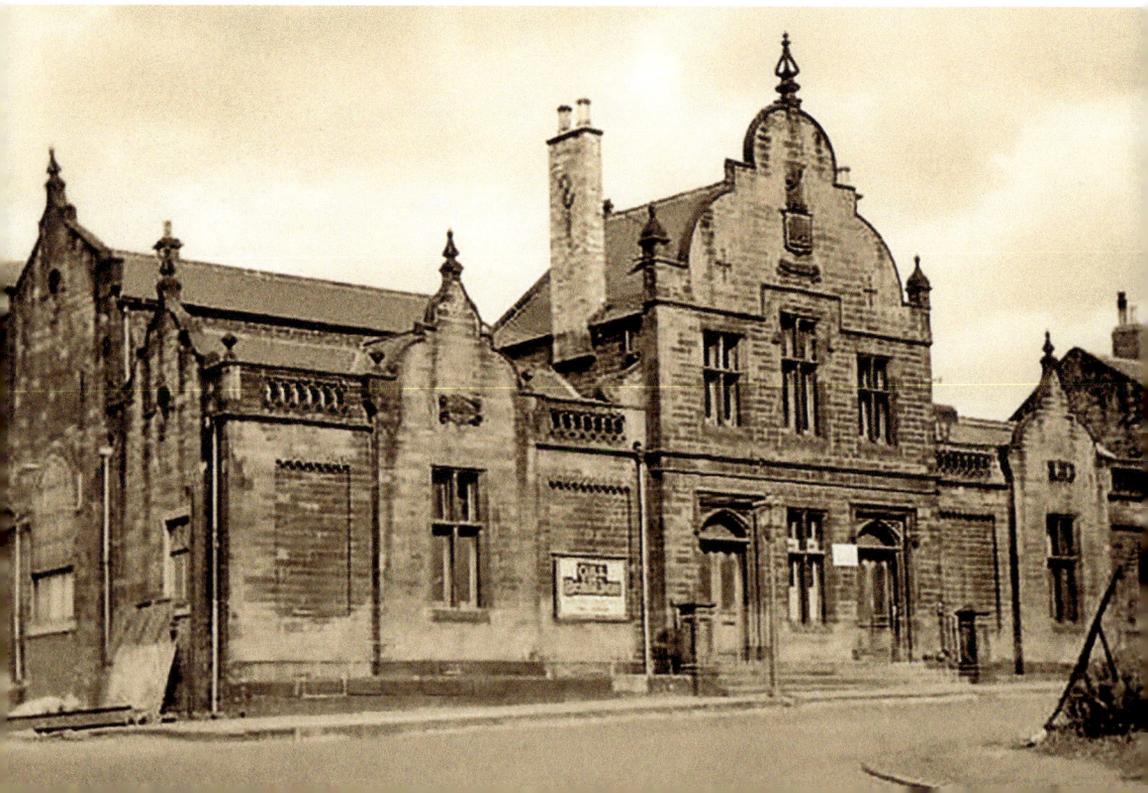

This ornate building, which cost £4,300, was designed by William Hall, the borough engineer. Opened in February 1855, this was an attempt to mitigate against the poor living conditions of residents of the area. Individual baths cost 6d for a hot bath and 2d for a cold bath. There were eighteen male and five female bath cubicles, but these were not well used. The washhouses were much better patronised at a cost of 1d per hour – in the early days an average of 400 people per week used these. They had areas for washing laundry and 'ingenious drying machines'. In August 1908, the premises were advertised to let as a laundry with facilities for public washing. The building was later used as a warehouse, before being destroyed by fire in 1986.

Oakwellgate baths and washhouses.

Odeon Cinema

Gateshead's grandest cinema was opened as Black's Regal cinema on 15 February 1937 by Gracie Fields, who enthralled the crowds by appearing on the flat roof of the foyer block from where she sang. It was built and operated by George and Alfred Black and its name was changed to the Odeon when that cinema chain took over in 1945. This large cinema could seat, 2,272 with 1,582 in the stalls and 690 in the circle, and a Compton organ was installed. By the late 1960s, the Odeon was one of only three cinemas left in the town. Both the town centre's other cinemas, the Ritz and the Essoldo, were later demolished to make way for the new A1 flyover, which it was hoped would increase the Odeon's business. Sadly, this proved not to be the case, and the cinema finally closed on 18 January 1975, with the last film to be shown being *Thunderbolt and Lightfoot*. It reopened in 1978 as a bingo hall, but was eventually demolished in late 2003.

Olympic Torch

The Olympic torch arrived outside St Mary's Heritage Centre, Oakwellgate, Gateshead, on Friday 15 June 2012. The torch bearer then ran to the Tyne Bridge to deliver it to TV adventurer Bear Grylls. Grylls, holding the Olympic torch, then completed a

Olympic torch being carried outside St Mary's Heritage Centre.

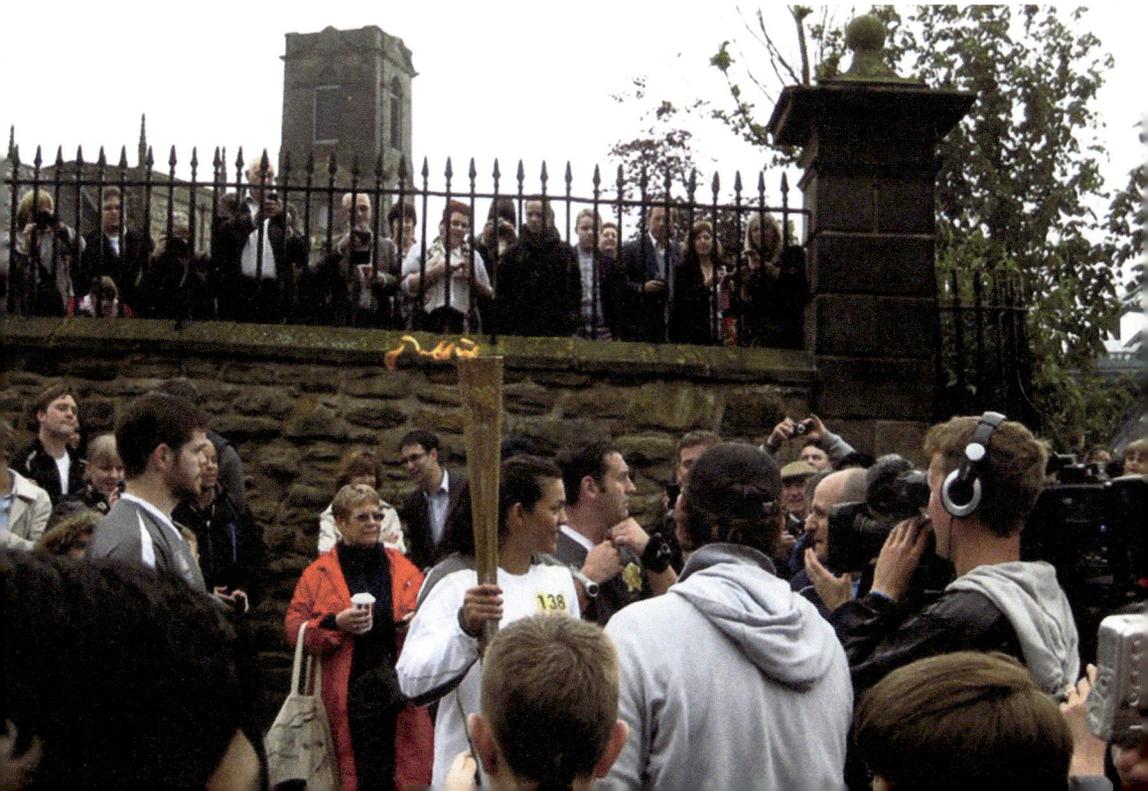

spectacular zip wire slide off the Tyne Bridge, with thousands of people lining both sides of the river below. The following day the torch travelled through Gateshead, starting by Richard Jackson, one of the Sage Gateshead's window cleaners, abseiling down the front of the Sage building. The route took in Hillgate, Bridge Street, Oakwellgate, Gateshead Highway, Park Lane and the Felling bypass. At Gateshead International Stadium it was taken on a lap around the track. It then visited the *Angel of the North* and travelled through Chowdene on its journey to Blaydon Leisure and Primary Care Centre and along Shibdon Road.

Open-air School

The idea of an open-air school was first considered in 1925. Work finally started on part of the Whinney House estate ten years later, and the school was opened as Joicey Road Open Air School on 25 May 1937 by the mayor of Gateshead. The school accommodated 150 children who were deemed too delicate to attend mainstream schools. Many of them suffered from conditions such as tuberculosis and asthma. Pupils' ages ranged from six to fourteen and children were housed in six classes. The children received meals during the day consisting of a snack in the morning then lunch, which was followed by a rest on beds in the rest shed and then tea in the afternoon during summer. The school day finished at 4.15 p.m. in winter and later during summer. Whenever possible, classes were conducted in the open air and in bad weather the children were taught in classrooms with folding windows on three sides. The open-air school closed in 1970, but continued as an educational establishment for some years.

The buildings are Grade II listed and the site has now been redeveloped into a business centre with some new buildings.

Open-air school on Joicey Road.

Oxberry, John (1857–1940)

John Oxberry was arguably Gateshead's most important local historian. He was born in Windy Nook in 1857, and as a young man emigrated to New Zealand to try his luck in the gold fields of Otago. He was unlucky, however, so tried again in Australia before finally returning to Gateshead. From 1885 to 1890 he was school attendance officer under the Heworth School Board. After that, until 1917 he was relieving officer under the Gateshead Board of Guardians, and from then until his retirement in 1930 he was superintendent registrar of Gateshead. Once he returned to Gateshead he began collecting local history items, and by the time of his death in 1940 had amassed a huge quantity of material. He was an active member of the Newcastle upon Tyne Society of Antiquaries for thirty-three years, as well as being a longstanding member of Gateshead Libraries Committee. In 1937, he was elected an Honorary Freeman of Gateshead and presented with a silver casket at a celebratory event in the Shipley Art Gallery.

John Oxberry receiving the Freedom of the Borough, 1937.

P

Park House

For many years, this was the home of Gateshead's Lord of the Manor, William Cotesworth, who virtually rebuilt it in 1723. The house was sheltered on the north by a row of large elm trees. Following Cotesworth's death in 1726, the house was occupied by his daughter Hannah who had married Henry Ellison. Henry greatly enlarged the house, which was approached by a drive from Sunderland Road. The area around the house was landscaped with trees, lawns and a fish pond. The Ellisons later moved to Hebburn and Park House was tenanted for a number of years. Two of its residents were Henry and Alfred Allhusen, who owned large chemical works in the area. In 1884, the house was bought by Clarke Chapman's and used as the company's drawing

Derelict ruins of Park House, *c.* 1989.

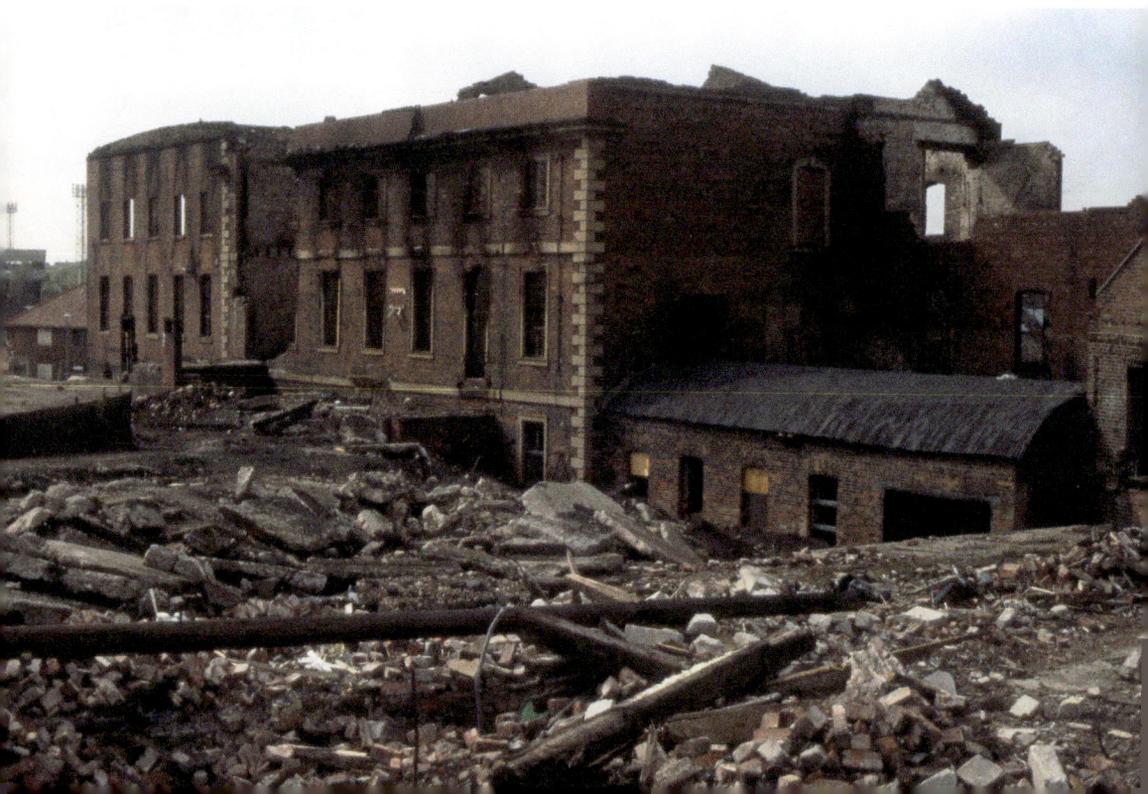

office. Gutted by fire in 1891, it was rebuilt but bore little resemblance to the fine house it had once been. For a time it was the home of the Sunbeam lamp works, but was eventually abandoned and lay derelict for some years before being destroyed by fire in 1990.

Park House was mistakenly thought to have been the Gateshead Hall mentioned in Charlotte Brönte's *Jane Eyre*, and this led to a number of streets in the area being given names such as Bronte Street, Jane Eyre Terrace and Shirley Street.

Perambulations of Gateshead

The purpose of a perambulation was to maintain the boundaries, ensuring that there were no trespassers and all was in order. Gateshead's first perambulation took place in 1649, with people walking or riding on horseback around Gateshead's original boundary. The churchwardens bought 1 stone of figs for 4s 6d, which were distributed to the children. This doesn't seem to have been enough, as the following year they added 1 stone of prunes to the stone of figs and paid a piper 3s to cheer the procession on their way. The perambulations stopped in 1792.

In 1824, after an absence of twenty-two years, the rector, John Collinson, revived the practice. A total of 200 copper tokens were ordered and distributed. They set off from St Mary's Church both on foot and on horseback at 9 a.m. with the bells ringing as they did so, while guns at a local glassworks fired a salute as the procession moved down Bridge Street towards the old Tyne Bridge. Here, two constables bearing flags mounted the parapet of the bridge and descended a ladder into the bed of the river below to assert Gateshead's right to one-third of the river's breadth. The two pipers who accompanied the procession played 'The Keel Row's Merry Hop'.

Perambulation token, 1824.

Perambulation, 2018.

From Pipewellgate, the party travelled to Chowdene and then to Wrekenton, where the churchwardens had provided a supply of bread, cheese and ale. The perambulation ended here, but the constables still had to complete their river survey, so they headed to Friar's Goose at East Gateshead where they rowed westward to the Tyne Bridge. There were three further perambulations in the nineteenth century, with the last being held in 1857.

In 2011 the perambulation was revived and since then members of Gateshead Local History Society have planned and led a group each year, continuing the old tradition.

Pottery

Although pottery was not one of Gateshead's main industries, a few potteries did exist, chiefly at Carr Hill and Sheriff Hill. Early potteries produced china made of brown clay, but John Warburton introduced white earthenware into the district in the mid-eighteenth century. He died in 1795 and after the deaths of his son and widow, the pottery had a variety of owners, the last being Thomas Patterson of the Sheriff Hill pottery. The pottery closed in 1893 and the building was demolished in 1932. The Sheriff Hill pottery was established by Paul Jackson in 1771 and was situated at the corner of Pottersway and Old Durham Road. His family continued to run it until Thomas Patterson took it over in 1837. Many of its employees lived in a row of cottages near the Old Cannon Inn. The pottery was demolished in the 1920s and the site used for council houses. Other earlier potteries existed at the South Shore and Pipewellgate.

Quarries

Stone was quarried in various areas of Gateshead from medieval times, with most of the stone being used to produce grindstones that were taken to Newcastle, from where they were exported. These stones were consequently, and mistakenly, referred to as Newcastle grindstones. By the end of the eighteenth century grindstone production in Gateshead was in decline, although walling stones were being quarried around the area of the High Street and Park estate. From the nineteenth century most of the Gateshead quarries were producing building stone. However, due to the amount of building that took place in Gateshead during the nineteenth century, by the 1890s most had been filled in and largely built over.

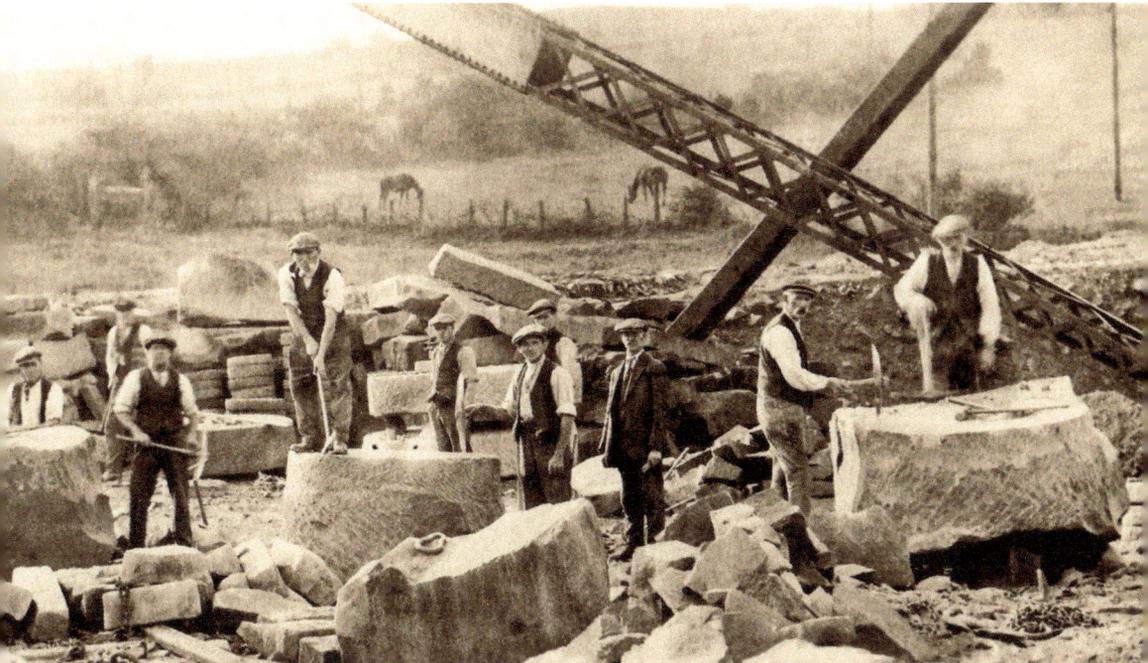

Shaping stone blocks for pulp stones, 1904.

Quayside Athletics

For the last ten years the Great North City Games has taken place as part of the Simplyhealth Great North Run weekend when both Gateshead and Newcastle quaysides are transformed to become an international sporting arena. The event is televised live by the BBC and attracts world-class sprinters, long jumpers and pole vaulters. Over 25,000 people come to the quayside to watch the games. Taking place on the same day is the Great North 5K, and junior and mini runs, followed on the Sunday by the Great North Run.

Queen Elizabeth Hospital

In the late 1930s, plans were drawn up for a major new hospital, estimated to cost £293,000, and for modernisation of the Infectious Diseases Hospital at a cost of £70,000.

The foundation stone was laid in September 1939 by Alderman Peter Strong Hancock (deputy mayor and chairman of the Health & Sanitary Committee) and Mrs Hall (vice chair of the committee). In 1943, it was announced that the new hospital would be known as the Queen Elizabeth Hospital, which was soon abbreviated to the 'QE'. Building work halted during the war but later resumed, and both medical and surgical facilities were in use by 1945. The QE was formally opened by Queen Elizabeth (wife of George VI) on 18 March 1948, just four months before the National Health Service began. A new art deco-style isolation block was also opened on the site, which meant that accommodation in the Isolation Hospital was increased to 120.

Over the years further improvements and extensions to the hospital have been made, and in 1968 the hospital began the first breast cancer screening service for women in the North East. Today, following a £32 million programme, a new state-of-the-art emergency care centre has been opened. The hospital is currently home to the North East Surgical Centre.

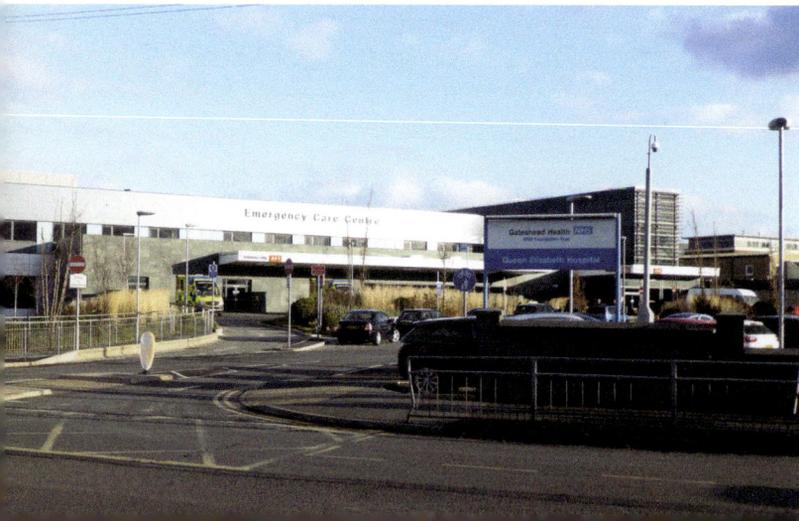

Queen Elizabeth Hospital.

Quin, Rt Hon. Baroness Joyce of Gateshead (b. 1944)

Joyce Quin was born in Tynemouth and was a scholar at Whitley Bay Grammar School. She gained first-class honours degree in French at Newcastle University, followed by a master's degree in international relations at the London School of Economics. She moved to Gateshead to live in 1979 when she was elected MP for Gateshead East. Prior to this she had been Member of the European Parliament for Tyne and Wear (including Gateshead), and before that had worked for some years as a lecturer in French and politics at Bath and Durham universities.

As an MP she served in a variety of shadow Ministerial and Ministerial roles, including as Minister of State for Europe, as Minister for Prisons and Probation, and as a Minister in the Ministry of Agriculture, Fisheries and Food. She successfully campaigned for the nationwide introduction of the concessionary bus travel scheme for pensioners.

Joyce was appointed to the Privy Council in 1998. She is an honorary fellow of Sunderland University and of St Mary's College, University of Durham. She was awarded the 'Legion d'Honneur' by the French government, and in 2006, the year she was appointed to the House of Lords, she was awarded the Freedom of the Borough of Gateshead. She is the author of a book on the British constitution, and has co-authored with Moira Kilkenny *Angels of the North: Notable Women of the North-East.*

Outside of politics she has always been keenly interested in North East local history, having been a Newcastle City Guide since 1976. She is president of the Northumbrian Pipers Society and is currently chair of the Strategic Board of Tyne and Wear Archives and Museums, which includes Gateshead's Shipley Art Gallery as one of its major assets.

Baroness Quin.

R

Ravensworth Castle

At one time, Ravensworth Castle was the oldest fortified house in Durham County. It was first mentioned as early as 1080 and by 1223 there are records of a manor house and deer park being owned by Robert de Yeland. By 1318 it had passed to the Lumley family, who remained there until around 1544. A castle is first mentioned in the early fifteenth century, which was possibly a manor house with a north tower, further additions being the curtain walls and the south tower. During the sixteenth century the estate was owned by the Gascoignes, who sold the estate (then referred to as Ravenshelm) to Thomas Liddell around 1607, and it was his son Thomas who became the first Lord Ravensworth. The family changed the castle over the years, constructing a great house within the castle walls in 1724, which was demolished in 1808 when only the north and south towers remained. Sir Thomas Henry Liddell rebuilt the castle in a Gothic style to a design by Nash in 1825. During his lifetime Ravensworth had many important visitors, including the Duke of Wellington and Sir Walter Scott, both of whom visited during 1827.

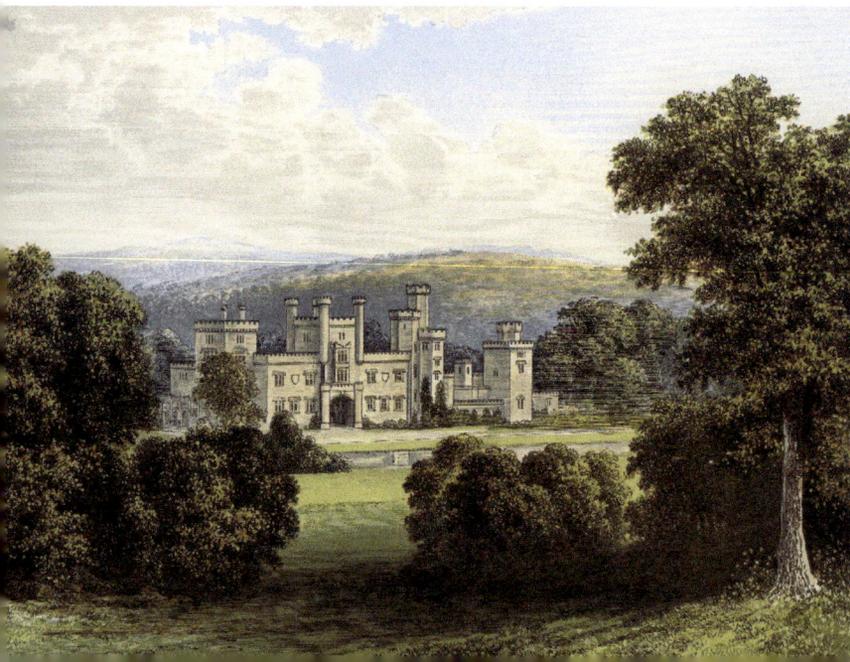

Ravensworth Castle, 1879.

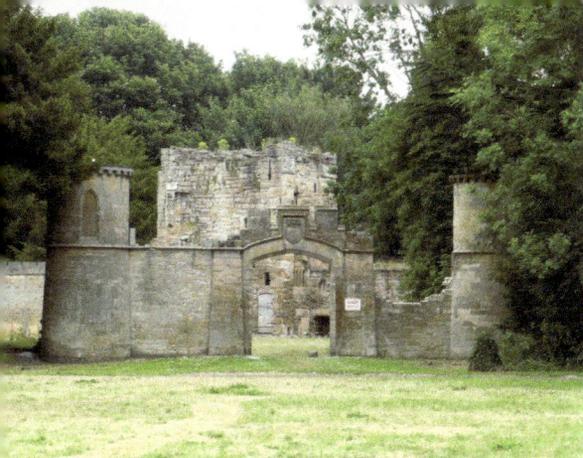

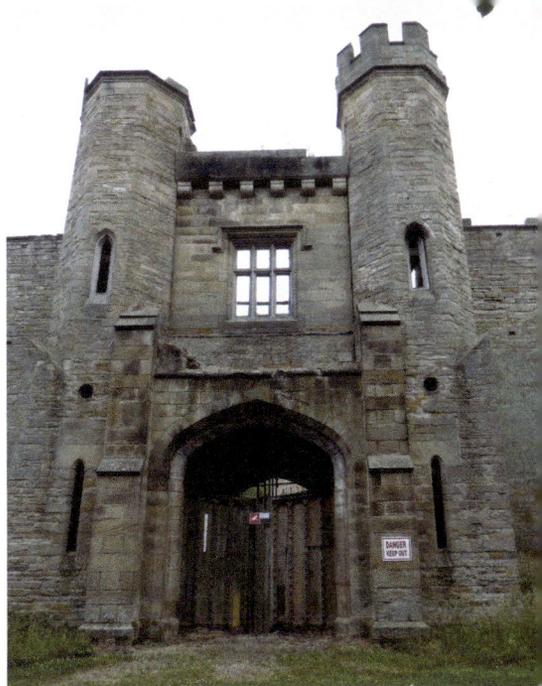

Above: Ravensworth Castle.

Right: Entrance gateway to the stables, Ravensworth Castle.

The castle had four storeys in ashlar sandstone and had an embattled and turreted exterior and an octagonal tower appearing above the trees. It was widely regarded as a beautiful romantic building. Surrounding the castle were landscaped gardens that included pleasure grounds, parkland, a fountain, conservatory and walled garden. By the late nineteenth century the family had reached both wealth and political influence due to coal mining, but after the 5th Baron's death in 1919 this started to decline. The family moved to Northumberland, selling off much of their grand furniture, china, bronzes, manuscripts, books and many art treasures, although the estate remained in their possession until 1976.

During the 1920s the castle was used as a girls' school and in 1934 and 1936 the grounds were used for military tattoos. The castle, however, was in decline by now and severe cracks started to appear due to mining directly below the house. Demolition started in the late 1930s by the 7th Lord Ravensworth. The stone was to be used to build a model village on the estate, but work had to stop for the Second World War and only three houses were built. After the war the village was never completed and by the 1950s only fragments of the castle remained, the two towers and the stable block. Further demolition took place in 1954.

Since 1 November 1985 the remains of Ravensworth Castle have been Grade II* listed and the building is on English Heritage's Buildings at Risk register.

Redheugh Bridges

Redheugh lies to the west of Gateshead, and there has been a bridge across the Tyne here since 1871. The first bridge built by Thomas Bouch (the architect of the ill-fated Tay Bridge in Scotland), who had a reputation for building bridges quickly. This bridge

was of a slender construction and by 1885 serious faults had developed. This meant that it was almost completely reconstructed between 1897 and 1901 using the piers of the old bridge.

Originally this was a toll bridge, but tolls were removed on 10 May 1937 (coronation day). By the 1960s serious design flaws once again became apparent. Speed restrictions of 10 mph and weight restrictions of between 8 and 10 tons were introduced, but these hindered the traffic flow. Eventually, it was decided that rather than try to repair the bridge, it would be cheaper to build a new one.

In 1983, after years of delay, a third Redheugh Bridge was built just 25 metres east of the old one, and was opened by Princess Diana. Constructed of prestressed concrete, it is able to carry loads of up to 400 tons and has a life expectancy of 120 years. Although the bridge is very streamlined and open, this causes problems for high-sided vehicles in strong winds.

The first Redheugh Bridge, 1895.

The present Redheugh Bridge under construction.

R

Renforth, James (1842–71)

James was born in New Pandon Street, Newcastle, but shortly after his birth the family moved to Rabbit Banks in the Pipewellgate area of Gateshead. From about the age of eleven, he was employed as a smith's striker. He began rowing purely as a means of earning extra money to support his wife and young family, and made his debut in 1866 in a sculling race, which he won easily. In 1870, an open challenge came from Canada to take on an American crew of four. Renforth and his crew won comfortably, but there were disagreements among the British team and the following year when asked to take on the challenge again, Renforth was forced to find a new crew. Harry Kelley, the famous London oarsman joined him with Bob Chambers, James Percy with John Bright as reserve.

The race started on the Kennebecasis River, New Brunswick, at 7 a.m. on 23 August 1871, with the British crew quickly overtaking the Americans. However, it was soon noticed that something was wrong with Renforth's rowing. He finally collapsed into the lap of Harry Kelley. Renforth was taken ashore but died shortly afterwards. It seems likely that after suffering an epileptic fit in the boat, he died of heart failure. His body was returned to Tyneside and he was buried in St Edmund's Cemetery, where his burial was attended by over 100,000 mourners. A suitable memorial was commissioned, which was removed from the cemetery in 1986 and relocated outside the Shipley Art Gallery, Gateshead. Inside St Mary's Church, Gateshead (now St Mary's Heritage Centre), a memorial plaque to Renforth can be seen, which was sculpted in Nova Scotia.

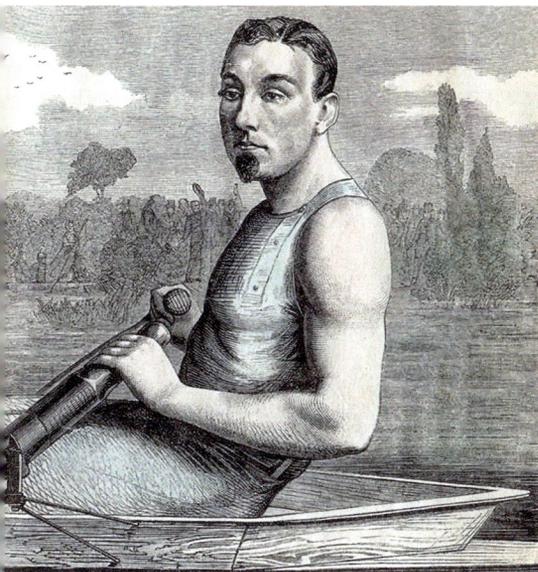
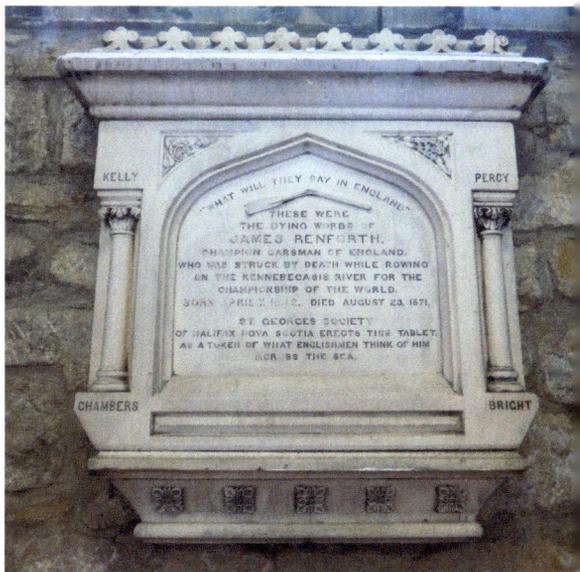

Above left: James Renforth.

Above right: Plaque to Renforth in St Mary's Church (now St Mary's Heritage Centre).

69

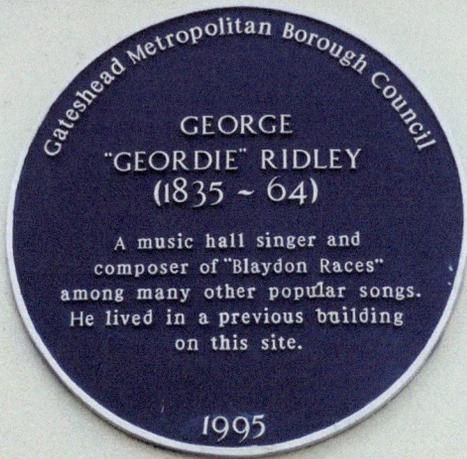

Ridley, Geordie (1835–64)

George (Geordie) Ridley will be forever remembered as the lyricist to the 'Geordie' anthem 'Blaydon Races', which is performed throughout the world. Born in Gateshead in 1835, he started work as a trapper boy in Oakwellgate Colliery, aged eight. By the age of eighteen he had moved to the engineering firm of Hawks, Crawshay & Co. where he was a wagon rider. Unfortunately, an out of control wagon left him severely injured and unfit for regular work. He earned a living after that by singing and performing Tyneside songs, many of a topical nature that appealed to local people and many of his songs were written in the local dialect. Sadly, Ridley never fully recovered from his injuries and after a short illness he died at his home in Grahamsley Street in the town centre.

He has a blue plaque dedicated to him, erected on the William IV public house in Gateshead's High Street, which was built on the site where he used to live.

River Tyne Police Station

Formed in 1845 at the instigation of local shipowners, the River Tyne police originally comprised twenty-one men and six rowing boats. As the nineteenth century progressed, river police stations were built at various locations along the Tyne, but

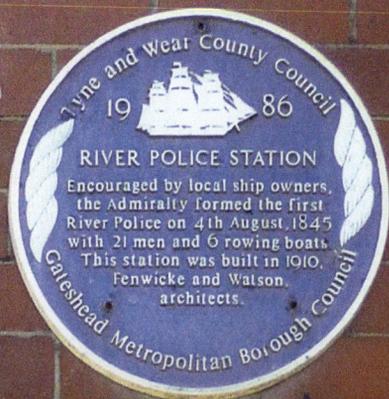

River Police blue plaque.

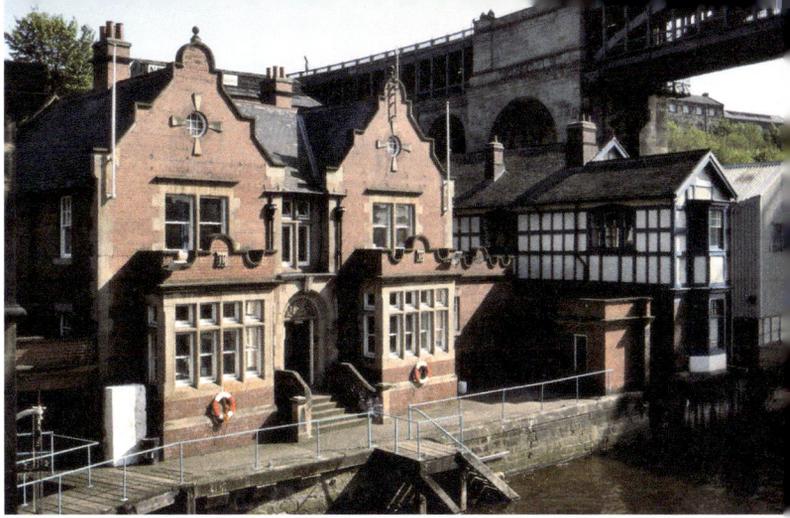

River Police Station, 1992.

Gateshead's station was the last to be constructed as it was not built until 1910. The architects were Fenwicke and Watson of Newcastle and it was situated at the south-west end of the Swing Bridge in Pipewellgate, Gateshead. The building contained cells for holding illegal immigrants from ships entering the Tyne. The police station closed some years ago and is now a restaurant.

Rope Industry

There were a number of rope-works in Gateshead. One of these was Haggie's, who were awarded a prize at the 1851 Great Exhibition. The firm made hemp and wire rope and had rope-works at the South Shore and Hillgate. In 1845, they produced a rope measuring 3 miles long and 8 inches in circumference with a weight of 13 tons for the Liverpool and Manchester Railway. This was too heavy to be moved by horses and eventually had to be taken by barge to Redheugh, where there was access to the railway. The firm also produced wire signal lines for railways. A fire destroyed their first wire-rope factory and a new one, known as the No. 1 or Old Ropery, was built in 1873. No. 2 was built in 1889, and by 1895 output was 2,500 tons a year. The factory was enlarged in 1900 and converted from steam power to electricity and by 1907 a total of 5,000 tons of wire rope were being produced. The output increased during the First World War, and in 1926 the firm joined the British Ropes combine.

Another firm was that of R. S. Newall and Company who established a factory in the Teams area of Gateshead making wire ropes for 'Mining, Railway, Ships' Rigging, and other purposes'. On 17 August 1840, Newall took out a patent for a new improved wire rope and new equipment for the laying of submarine telegraph cables using gutta percha surrounded by strong wires.

The Newall works produced the first successful undersea cable, laid between Dover and Calais on 25 September 1851, following which manufacture was continued on a large scale. Newall often directed the submergence of many of his cables, which included several lines in the Mediterranean. The rope that brought Cleopatra's Needle from Alexandria to London was made by Newall's.

Sage Gateshead

Sage Gateshead is a concert venue and also a centre for musical education, built on an area once known as Rector's Field on the south bank of the River Tyne. It was designed by Foster and Partners, who won an architectural competition to do so, and it has won a number of architectural awards including the Journal North East Landmark of the Year Award. It opened in 2004 and contains two concert halls, the Northern Rock Foundation Hall and teaching studios, all of which have acoustic curtains that can reduce loudness and also increase clarity for amplified music and speech. The main concert hall can seat 1,700, while the second, possibly the only ten-sided performance space in the world, can seat 450. The three halls are actually three separate buildings that are insulated from each other. They are surrounded by a glass and steel shell. The building is tenanted by the Board of Sage Gateshead (formally the North Music Trust) and is home to the Royal Northern Sinfonia, described by *The Guardian* as 'no better chamber orchestra in Britain' and regularly hosts visiting orchestras from around the world.

East door of the Sage Gateshead.

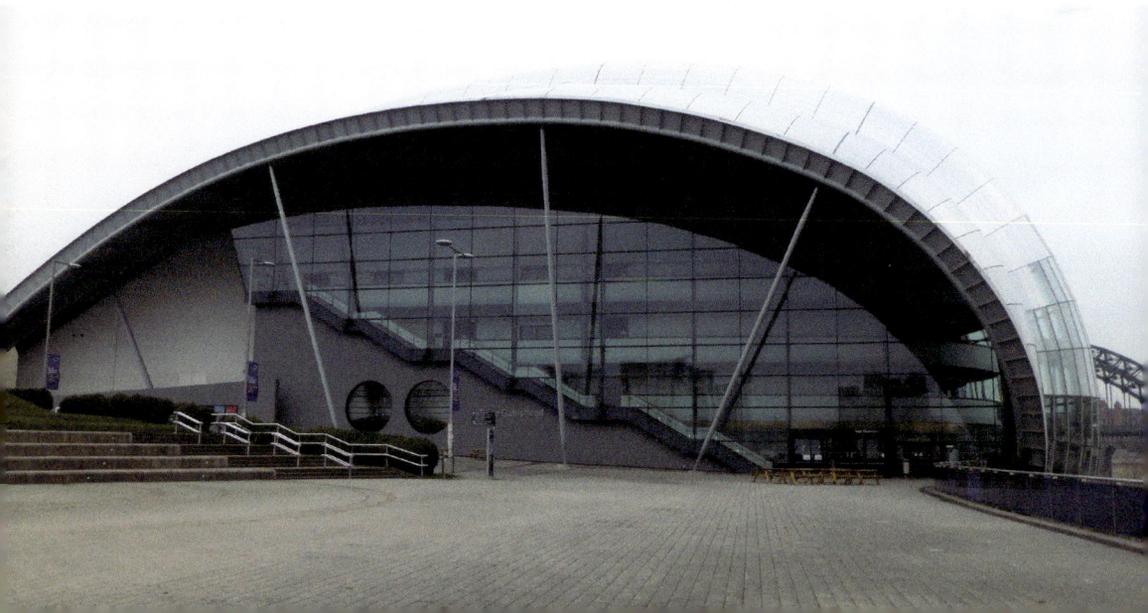

Sage Gateshead and the Tall Ships, 2005.

St Mary's Church

This church is Gateshead's 'mother church'. It opened in the twelfth century, with possibly at least one earlier church having previously occupied the site. Despite the creation of other churches and parishes in Gateshead, it was usually St Mary's that remained the venue for major services in the town and many civic services, especially that of Mayor's Sunday, took place here. In the 1930s Gateshead's slum-clearance programme virtually cleared the church of resident parishioners. The church closed in 1979 after a disastrous fire, which was compounded by a further fire four years later. Later uses of the building have included an auction house and a visitor centre. In 2009, Prince Edward, the Duke of Wessex, formally opened the building as St Mary's Heritage Centre.

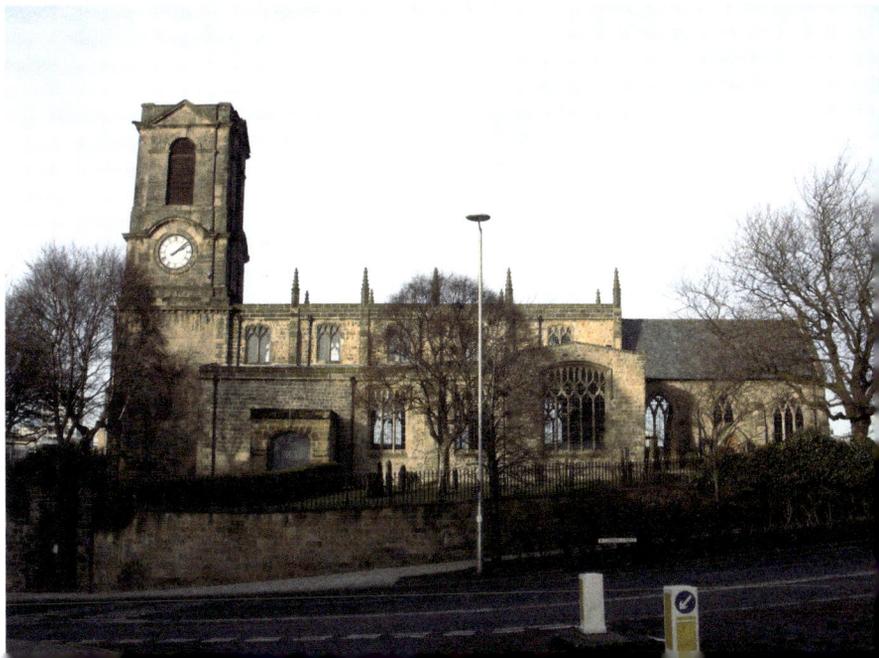

St Mary's Heritage Centre (formerly St Mary's Chuch).

St Mary's Heritage Centre interior.

Saltwell Park

Saltwell Park was opened in May 1876 on lands formerly owned by William Wailes, a local stained-glass manufacturer. Gateshead Council obtained a government grant of £30,000 to buy the land and Wailes' mansion house (now known as Saltwell Towers), which he was allowed to rent. The grant also paid for the landscaping of the 55-acre grounds, which was done by Edward Kemp, a well-known landscape architect and garden writer. Kemp laid out a promenade (the Broad Walk), designed structures such as a drinking fountain and provided plans for various recreational areas such as tennis courts and bowling greens. He also identified a space for a lake, although this was not built until 1880.

After Wailes' death the house was tenanted, used as a convalescent home and a VAD hospital, and then in the 1930s converted to use as the town's museum. However, due to its poor construction, the house was eventually closed and boarded up.

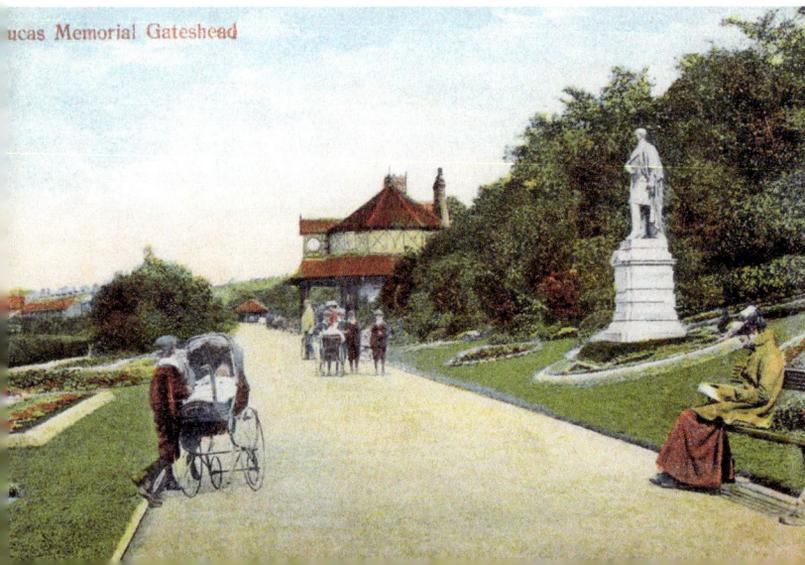

The Broad Walk Saltwell Park, c. 1910.

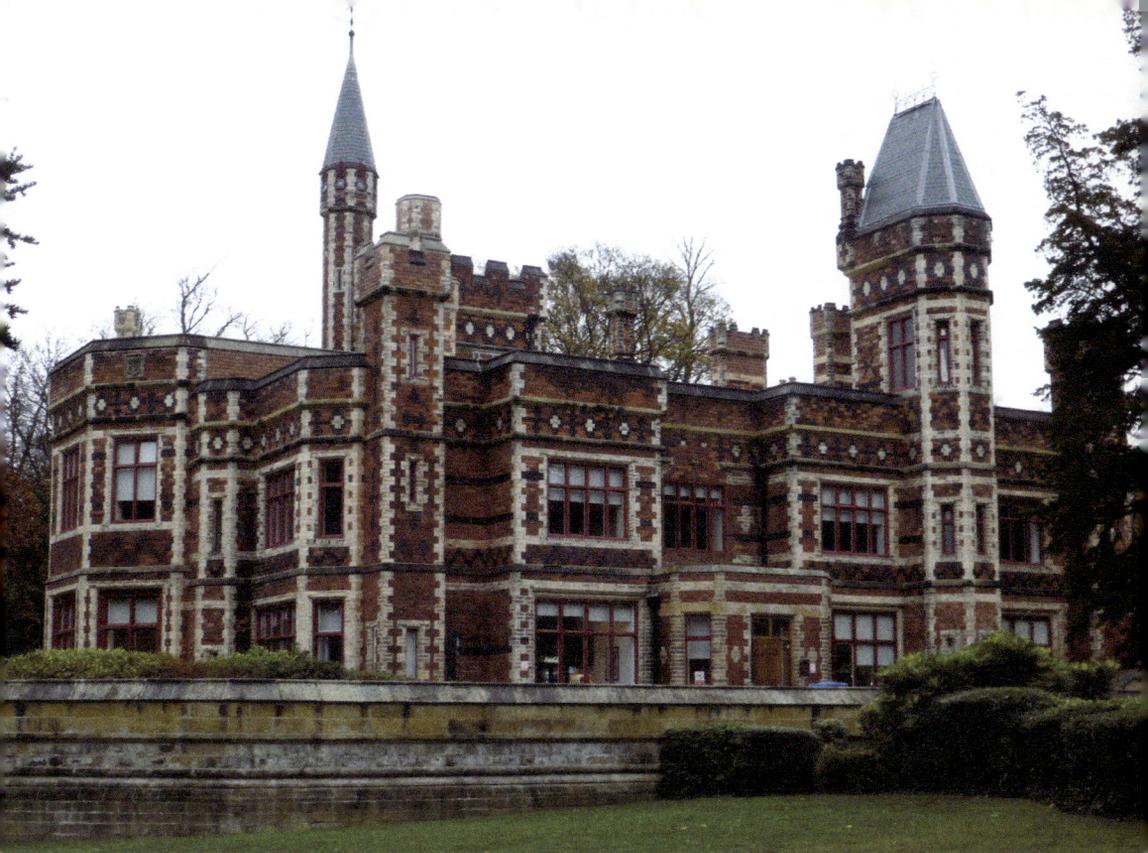

Saltwell Towers.

A successful Heritage Lottery bid together with input from Gateshead Council provided the money for a £10 million restoration of the house and park, with the house reopening as a café in 2004. Since then, Saltwell Park has been voted Britain's Best Park and regularly wins Green Flag awards.

In the park there are a number of memorials to various wars, a statue to a former mayor of Gateshead, Alderman John Lucas, and a number of modern sculptures – part of Gateshead's public art programme.

Scott, Dixon (1883–1939)

Dixon Scott was a local film entrepreneur who built the Tyneside Cinema in Newcastle, which opened as the Newcastle News Theatre on 1 February 1937. Scott's travels to the Middle and Far East influenced the décor for the inside of the theatre, with gold, green and purple; some of these features were brought back to life when the cinema was restored in 2018. During the early twentieth century Scott lived in a house called The Datcha in Alverstone Avenue, Low Fell, with his wife and children. Dixon Scott died in 1939 and is buried in Cairo. He was the great-uncle of Sir Ridley Scott, director of films such as *Gladiator* and *Alien,* and the late Tony Scott, director of *Top Gun* and *Days of Thunder.*

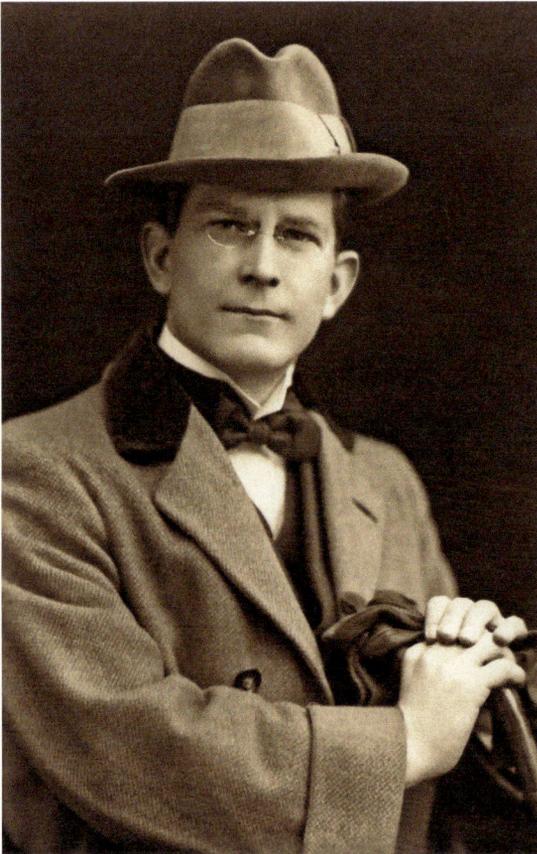

Dixon Scott. (Courtesy of Tyneside Cinema)

Shipley Art Gallery

Situated on Prince Consort Road, the gallery is a Grade II listed building, the money for which came from wealthy Gateshead-born solicitor and art collector Joseph Ainsley Davidson Shipley, who died in 1909. In his will he donated his 2,500 paintings and provided £30,000 to build a gallery to house them. Originally, his bequest was made to the city of Newcastle, who declined the offer largely due to the fact that many of Shipley's paintings were regarded as copies. Under the terms of the will, Gateshead Council was then offered the bequest. They decided to take 504 of the best pictures, with the rest being sold at auction. The gallery opened in 1917 and today has over 800 paintings. The gallery is a national centre for contemporary craft and it has one of the best collections outside London, including ceramics, wood, metal, glass, textiles and furniture. The Shipley is also home to the Henry Rothschild collection of studio ceramics. One of the most interesting paintings in the gallery is *The Blaydon Races* by William C. Irving. It shows the characters mentioned in the famous song written by Gateshead man Geordie Ridley.

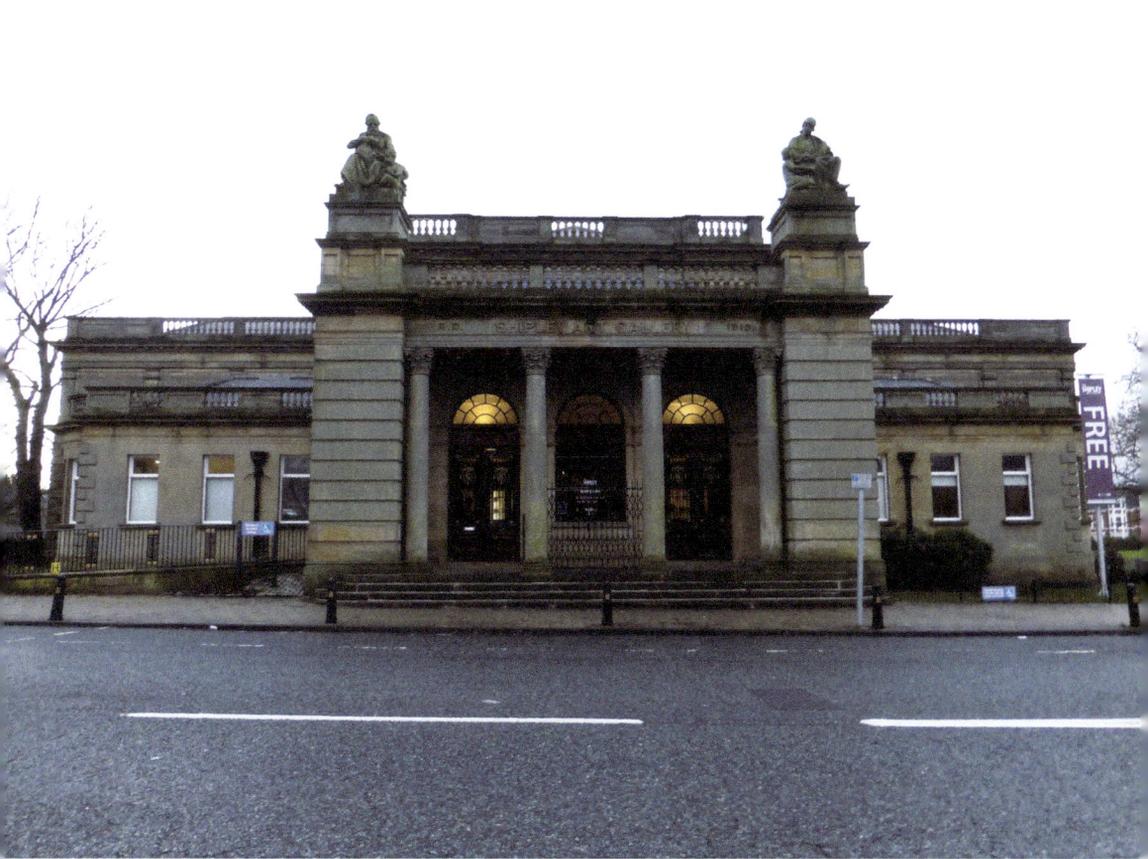

Shipley Art Gallery.

Shopping Service

When Gateshead resident Mrs Jane Snowball placed an order with her local Tesco supermarket in May 1984, she became the world's first online home shopper.

The Gateshead Shopping Information Service (known as SiS) was part of a scheme originally set up to save families the time and trouble of the weekly shopping trip. Rediffusion Computers (based in West Auckland, County Durham) built the hardware and software, based on a system invented by Michael Aldrich in 1979. Tesco was the first retailer to sign up, and on 1 April 1981 a microcomputer at a branch library linked with a microcomputer in Tesco's Gateshead branch. Soon the network was extended to two further libraries with two more retailers, Greggs the Bakers and Lloyds Pharmacy, signing up in 1983. As the system lacked an interactive link to retailers, however, the focus changed to helping disabled and housebound people get their groceries and other supplies.

When the service finally launched in 1984, it used an £80,000 Videotex system, which was installed in people's homes and worked through a modified TV set and remote control. There were 1,350 available products through the system, which could be delivered from the retailer to the shopper within hours of placing an order. The scheme ran until the late 1990s, when the Internet rendered it obsolete.

Team Valley Trading Estate

This estate, the first government-sponsored trading estate in the world, was formally opened on 22 February 1939 by George VI. Trading estates arose out of the Depression. By the 1930s, most of the major industries in Gateshead had closed and the whole of Tyneside had been designated a 'derelict' area. The North Eastern Development Board was formed in 1935, and in the October they issued a report recommending the establishment of trading estates. Various locations in the area were visited by the Government Commissioner for Special Areas. In May 1936, the North Eastern Trading Estates Limited was formed with government funds.

The Saltmeadows area was the initial location, but at the last minute it was decided to site the estate on the Team Valley, where construction began in August 1936. This 700-acre site was well situated for light industry, although much work had to be done. Traditionally pasture land, the site was boggy and subject to frequent flooding so had to be stabilised with millions of tons of colliery waste. The River Team, which ran through the site, had to be canalised.

George Wimpey & Co. received the first contract for roads and services in October 1936 and the main road through the estate, Kingsway, at 174 feet wide, was the widest road in Britain at the time of building.

George VI and Queen Elizabeth at the opening of the Team Valley.

St George's
House,
Team Valley.

The boast at the time was that it only took seventy-five days to build a factory ready to move into. Apart from factories there were also other buildings on the estate, including two garages, two banks and a post office. Havmor Ltd (makers of meat pies and sausages) was the first firm to move onto the estate and other early firms included Cadburys, Hunters the Bakers, Mellolite Ltd (makers of lampshades) and Hugh Wood & Company, who made mining machinery.

Today many of the original factories have been replaced by modern industrial units and the estate now houses a small shopping village and a larger retail park.

Theatre Royal

This building on the High Street was the scene of a pantomime tragedy when nine children and a doorkeeper were crushed to death after a false fire alarm. On Boxing Day 1891, in the middle of the matinee performance of *Aladdin and his Magical Lamp*, there came the cry of 'fire, fire!' Immediately there was panic. Children, many of them in the upper circle, were manhandled down over the heads of audiences below. There was a rush for the exit door, but there was only one door serving as both exit and entrance and it opened inwards. Following this disaster, new regulations came into force for theatres to have two separate outside opening doors.

The fire at the Theatre Royal had been caused when a boy had dropped a penny, lit a match to look for it, dropped the match and it set fire to some papers. Only two buckets of water were needed to extinguish the fire. In a further twist of fate, when the actors returned to their dressing rooms they discovered that many of their clothes had been stolen by opportunist thieves. The theatre closed immediately after the fire and reopened as the Queen's Theatre in 1894. After a variety of uses, the building was demolished in 1923.

Trinity Square

Trinity Square was opened in 1967, located in the area between High Street, West Street and Ellison Street. It comprised shops, banks, a public house, cafés and a multistorey car park with walkways around the second level of shops. The construction was of concrete and designed by Rodney Gordon, who worked for Owen Luder, an advocate of what has become known as the brutalist style of architecture.

The car park was opened later in 1967 and had seven parking levels above the shopping area. The top floor had been designed as a café, with large windows providing views across the River Tyne. Unfortunately the rooftop café failed to find a tenant and was never opened. The car park was the location of several scenes in the 1971 film *Get Carter*, the most famous being when local businessman Cliff Brumby played by Brian Mosley was pushed over a flight of stairs by Jack Carter played by Michael Caine. After this the car park was nicknamed 'Get Carter Car Park'.

In 2010 demolition of the shopping centre began to make way for a new shopping complex. Although many people signed a petition to retain the car park, this was in vain and demolition started on 26 July 2010, with Gateshead Council selling off pieces of the car park as souvenirs.

Trinity Square is now home to a variety of shops and cafés, a nine-screen Vue cinema, a health centre, office accommodation, and student accommodation for Northumbria University. There is also a contemporary public square with an impressive 27-foot sculpture, *Halo*, by artist Stephen Newby.

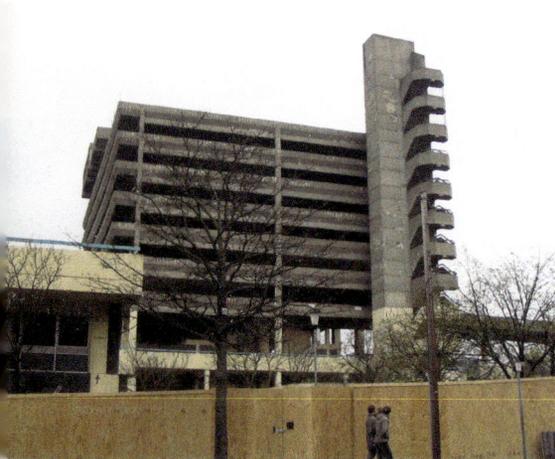

Above left: The 'Get Carter Car Park'.

Above right: Trinity Square.

U

Underhill

Underhill in Low Fell was the first house in the world to be lit by incandescent electric light. Its most notable resident was Joseph Swan, who was born on 31 October 1828 at Pallion Hall in Sunderland. He came to Gateshead around 1845 to join his brother-in-law John Mawson, who had a chemist shop and chemical works in Newcastle.

Swan conducted most of his experiments in the large conservatory at Underhill. By 1871 he had devised a method of drying the wet plates, initiating the age of convenience in photography, for which he received the first patent in 1878.

At the Newcastle Chemical Society on 18 December 1878, Swan demonstrated his incandescent electric light bulb, later demonstrating his new lamp to over 700 people at the Literary and Philosophical Society in Newcastle in February 1879. Underhill later became a private school and is now sheltered housing, where the first electric light switch ever made can still be seen.

Underhill.

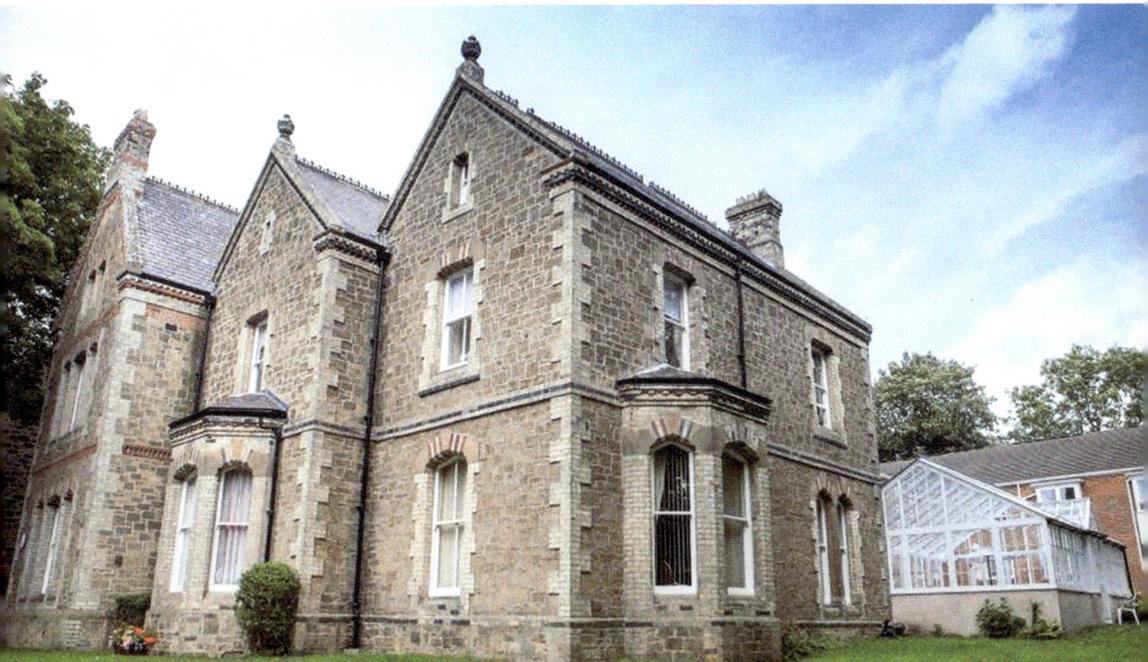

Union Workhouse

The Gateshead Poor Law Union was formed on 12 December 1836, and the first meeting of the Board of Guardians was held in the Goat Inn, Bottle Bank, two days later. The board soon decided that the five existing workhouses were inadequate and a new workhouse was required.

The site for the new building was Rector's Field, later named Union Row, and was completed on 13 July 1841. Built to accommodate 276 inmates, the workhouse was regularly overcrowded, which resulted in inmates sleeping two to a bed, with no separation between adults and children.

In 1851, a sick ward was added, and further extensions were planned but were no longer possible due to limited land in the area. This meant a new site was required and in 1885 the board accepted the offer of High Teams Farm at Bensham.

A competition was held in 1885 for plans for the new workhouse, and Messrs Newcombe and Knowles of Newcastle-upon-Tyne, and J. H. Morton of South Shields were joint winners. The new workhouse was to accommodate 922 inmates at an estimated cost of £40,110 and was completed in 1890. It comprised an entrance block with a porter's lodge, a main building at the centre of the site, administrative offices, a hospital, kitchens and a school for 300 children. It also had separate wards for males and females. The Union Row site was sold off in the early 1890s and Woodbine Street was erected on the site.

In 1938, the institution's hospital facilities separated to become Bensham General Hospital. The remainder of the establishment was renamed Fountain View after 1948 and provided hostel accommodation for the homeless. Most of the workhouse buildings were demolished in 1969.

Utta

The Venerable Bede talks about Utta who, in 653, was 'a renowned priest' and abbot of the monastery at Gateshead. Utta was the brother of Adda, who was one of four priests chosen to convert the Mercians to Christianity in the time of Peada. Peada had converted to Christianity when he married the daughter of King Oswy of Northumbria. King Oswy commissioned Utta to become his ambassador in Kent and it was during a voyage from Kent to Northumbria that Utta poured some hallowed oil, given to him by Aidan, on to the sea during a storm. This is believed to be the first time that 'oil was poured on troubled waters' to calm the sea. There is now no trace of the monastery at Gateshead, but it may have been situated near to the Hospital of St Edmund on the High Street.

V

Venture Coaches

Venture coaches were based at Lady Park near Ravensworth Castle and were established in the 1930s. They used old-fashioned carriages drawn by six white horses, all of whose names began with the letter 'V'.

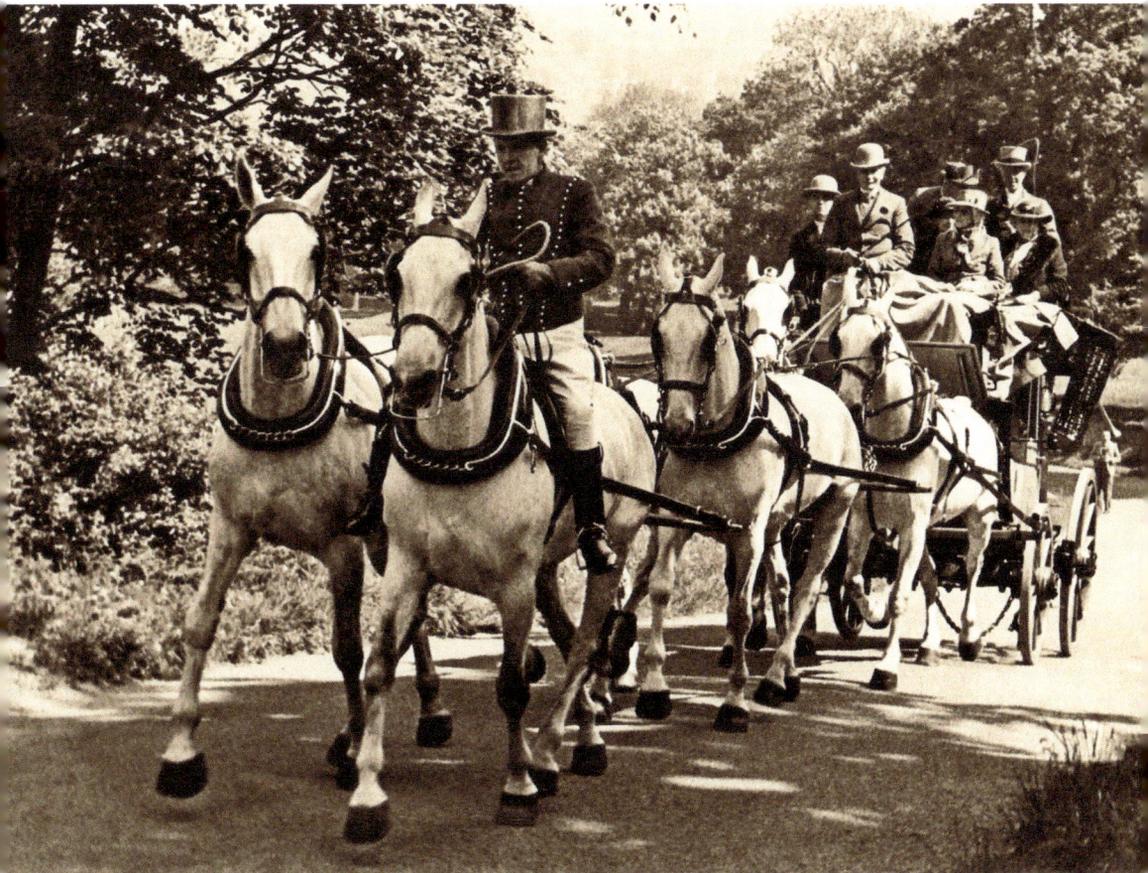

Venture coach, 1939.

Vine Street Mission

A mission was built in Vine Street in the Teams area of Gateshead in 1887 by miner Peter Shepherd, but eventually fell into disuse. In 1916, Sister Winifred Laver, a twenty-eight-year-old trained medical nurse and Methodist deaconess came to Gateshead to restart the mission. In settling in Gateshead, Winifred ignored parental disapproval and her doctor's warning that as a former tuberculosis sufferer herself, she would not last a year in Gateshead, which was then regarded as the tuberculosis capital of England. She came to the dilapidated mission and reopened it with the aim 'to help unfortunate people'. Until her death at the age of ninety-two, Winifred worked tirelessly in the mission, seeing to the health, food and clothing needs of the local poor. She visited homes, organised building work and repairs, started Boys' and Girls' Brigades, Scouts and Guides, and took hordes of children on seaside outings, all on a shoestring budget. The original mission was eventually demolished and a new building opened on 26 February 1977, renamed Gateshead Evangelical Church. Sister Winifred was honoured with an MBE and the Freedom of Gateshead, and outside the mission today a blue plaque can be seen that was erected to her in 2011.

Voluntary Aid Detachment Hospitals

In 1909, the British Red Cross Society got the task of providing supplementary aid to the Territorial Forces Medical Service in the event of war. Local branches established units called Voluntary Aid Detachments – VADs for short – with members trained in first aid and nursing. From an initial 6,000, numbers dramatically increased with the outbreak of the First World War when owners of large houses and mansions began to offer their properties as hospitals. Gateshead's Whinney House was the first in the town to be so used, and then in 1916 an offshoot hospital opened at Saltwell Towers. Nine wards were created here, holding fifty beds.

While in hospital the men wore a special uniform, which became known as 'hospital blues'. Local people held concerts and other amusements for the recovering soldiers and also raised much-needed funds. Men were often taken out to the cinema and the theatre, and were encouraged to be as active as possible. Enough were occupied doing needlework for Whinney House to hold an exhibition in December 1917 of the men's work, with prizes.

Many of the female volunteers received awards for their service, and the Gateshead volunteers were no exception. One of them, Mrs Janet Appleton, who was quartermaster at both Whinney House and then Saltwell Towers, was awarded an MBE. Two ambulances were presented by Sir James Knott, the Tyneside shipping magnate, to Saltwell Towers.

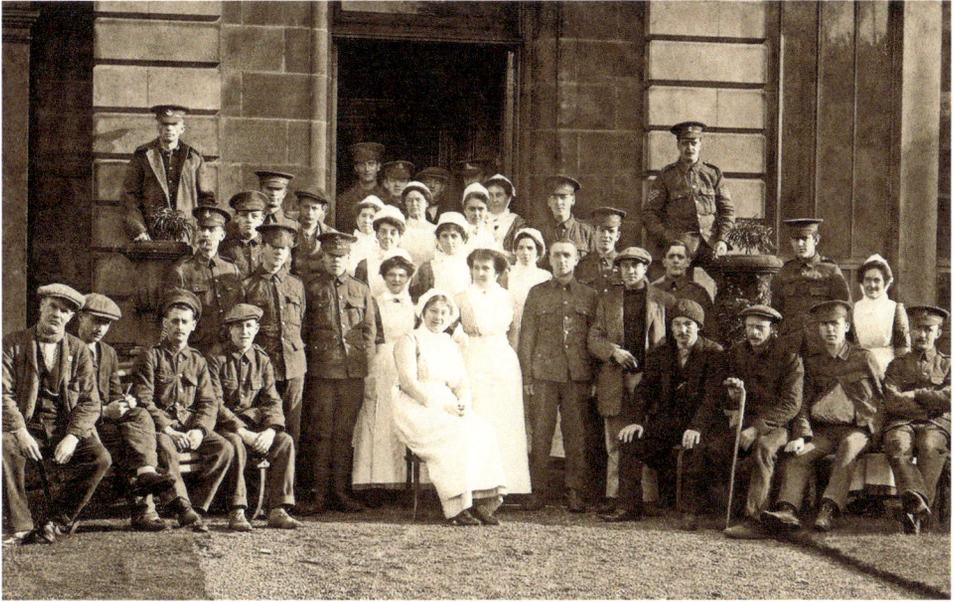

Whinney House, VAD Hospital, *c.* 1916.

Vulcan

The *Vulcan* is credited as being the first iron boat to be built in Gateshead. It was built by an employee of the Hawks ironworks, James Smith, who bought metal from the company for this purpose. However, when it was discovered why he wanted the metal, Sir Robert Shafto Hawks reimbursed him.

The boat was 31 feet long and took part in the Barge Day procession in 1823. Sadly both boat and builder came to sad ends. James Smith was later drowned in the Tyne, with the crew of his boat having 'too much beer and too little ballast'; while on Ascension Day 1826, when taking part in a Barge Day procession, two of *Vulcan*'s rowers were killed after a collision between two other vessels. After this, *Vulcan* lay abandoned. A public house in the Saltmeadows area of Gateshead was later named after it.

W

Wailes, William (1808–81)

William was born in Newcastle in 1808. His first business was as a grocer and tea merchant, but his first love was stained glass. Even as a grocer, his artistic talent set him off making small decorative pieces in enamel and selling them in his shop. In 1830 he travelled to Munich in Germany to study stained-glass design and production. On his return to England, he began the manufacture of stained glass in the rear premises of his shop.

The noted architect Augustus Welby Pugin, who had been commissioned to design St Mary's RC Church (now Cathedral) in Newcastle, asked Wailes to manufacture stained glass for the building. He went on to become one of the most prolific stained-glass manufacturers in Britain and his windows can be found in churches and cathedrals throughout the country. Wailes employed a number of designers who later went on to make names for themselves and was one of the twenty-five stained-glass manufacturers who exhibited their goods at the Great Exhibition in the Crystal Palace in 1851.

In 1853, Wailes bought the Saltwell Cottage Estate and set to landscaping the grounds and building himself a Gothic mansion – Saltwell Park House, later to be named Saltwell Towers. In 1875 he sold the property and estate to Gateshead Council to provide a public park with the proviso that he could live in the house until his

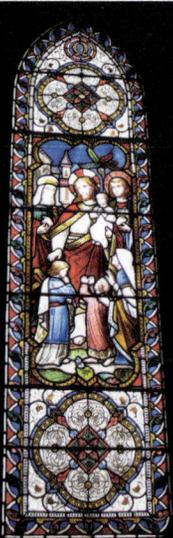

William Wailes window, St Helen's Church, Low Fell.
(Courtesy of Roger Fern)

death. His son William Thomas Wailes and his son-in-law Thomas Rankine Strang continued the manufacture of stained glass until 1910.

A blue plaque to William Wailes was unveiled on the exterior of Saltwell Towers in 2005.

Walcher, William (d. 1080)

After the Norman Conquest, William Walcher of Loraine was installed as bishop of Durham. He had bought the earldom of Northumberland, to the dismay of the Saxons, one of whom, Lyulph (an ancestor of the Lumley family of Lumley Castle), had protested and been murdered. The local Saxons assumed that the bishop of Durham's men were responsible and the amount of unrest that followed prompted the bishop to hold an assembly in an attempt at appeasement. Walcher offered to meet and explain his innocence to Lyulph's relatives in Gateshead.

On 14 May 1080, Walcher came to Gateshead with a large group of followers and soldiers. Despite protesting his innocence and grief, people remained angry and accused him of not having brought the perpetrators to justice. Fearing for his life, he and his followers fled into the nearby St Mary's Church. The church was then set on fire and one by one the Normans were forced to leave and were killed. Walcher's pleas were of little avail and, with shouts of 'Short rede, good rede, slay ye the bishop', the crowd hacked him to death. (*Rede* is an Anglo-Saxon word meaning plan or solution, advice or counsel). Walcher's badly mutilated body was eventually recovered by monks from Jarrow and taken to Durham Cathedral where he is buried in the chapter house. The action resulted in William the Conqueror's half-brother laying waste to the area.

Wesley, John

John Wesley paid frequent visits to Gateshead, calling the area of The Fell 'the Kingswood of the North' and frequently mentioned it in his diaries along with 'Chowden' (Chowdene). His first visit was on 10 July 1743. He visited here on at least seven other occasions and for nearly all of them he preached in a house erected in around 1753 by baker William Bell on today's Church Road, Low Fell. Under Bell's will, the house was bequeathed for use as a chapel and it became the first recorded Methodist chapel in County Durham. A gallery ran around three sides and a Sunday school was established in 1784. In the grounds was a sycamore tree and John Wesley often preached in its shade when the chapel was too full, or on a stone reached by a few steps. Eventually, however, as Low Fell's population started to rise, the chapel became too small and a replacement was needed. This was opened on a raised site on Durham Road in 1883 as a large chapel with a hall attached. The huge stone on which Wesley stood was engraved and mounted into the west wall of the hall.

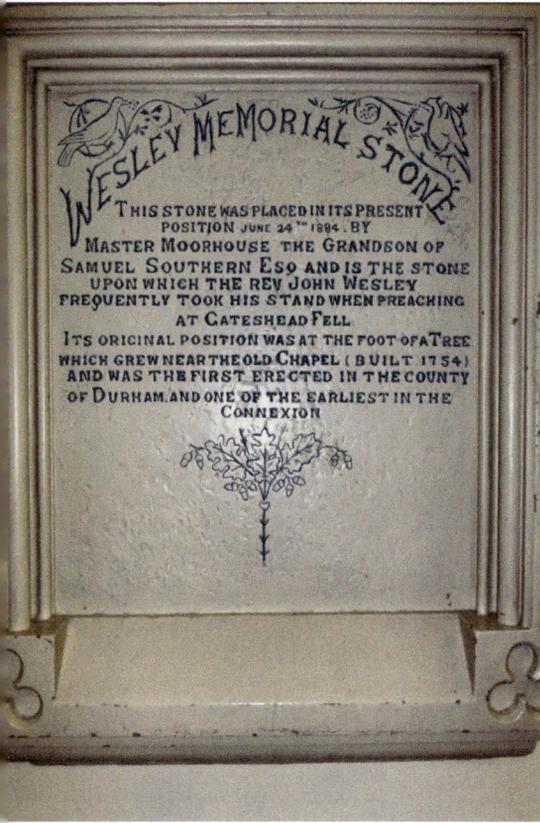

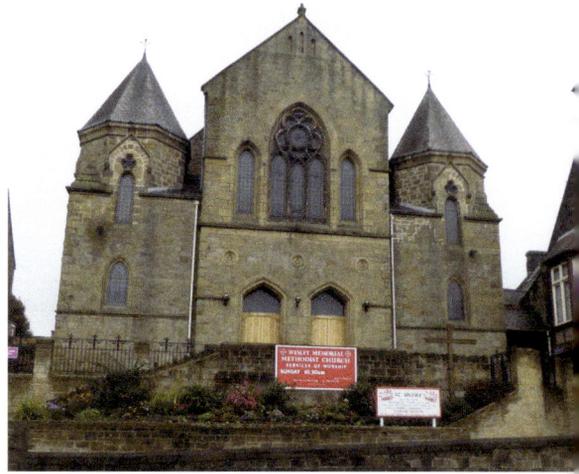

Above: Wesley Memorial Methodist Church, Low Fell.

Left: Wesley Memorial stone.

Windmill Hills

Gateshead had windmills as early as the fourteenth century, a number of which were located on high ground, which became known as the Windmill Hills.

An early mention of Windmill Hills came during the English Civil War, where in 1644 a conflict took place. The Earl of Callendar's Scottish troops, which were in alliance with the English Parliamentary forces, defeated Royalist troops who had to retreat to Newcastle. Five batteries of cannon were set up on Windmill Hills and for three weeks Parliamentarians and Royalists bombarded each other across the River Tyne. This became known as the Battle of Windmill Hills.

In the late eighteenth and early nineteenth centuries, during the Napoleonic Wars, the Gateshead Volunteers used the hills as an exercise ground and it was also used for the Whitsuntide hoppings. The area was also used for the hustings in the 1868 election.

Windmill Hills had been common land of medieval origin, retained by the borough holders and freemen collectively, although by the mid-nineteenth century parts were being sold off for housing development. Then, in 1861, it was conveyed to Gateshead

Corporation and became the town's first public park, with the ceremony marked by a general holiday in the town. Today two plaques stand at either side of the gate into Windmill Hills Park, off Bensham Road, a little reminder of the battle that took place here.

Above: Windmill Hills.

Below: Cavaliers and Roundheads on gateposts to Windmill Hills.

X Marks Your Candidate

Traditionally an 'X' has always been how electors have selected their chosen candidate in Parliamentary elections. Gateshead did not have its own Member of Parliament until after the Great Reform Act of 1832 when Cuthbert Rippon of Stanhope Castle was elected unopposed by the 500 Gateshead men who then had the vote. One of the prime movers in achieving Parliamentary representation for Gateshead was William Henry Brockett, who came up with the then novel idea of pre-printing ballot papers with the names of candidates. These were used primarily for the local elections, which were first held in Gateshead in 1835. There were then eighteen councillors, five of whom were elected aldermen. Today there are sixty-six councillors.

An example of W. H. Brockett's electioneering poster.

Xmas in Gateshead

Some notable events in Gateshead have occurred on, or around, Christmastime – unfortunately not all of them happy occasions. On 27 December 1793, fourteen souls were 'hurried' into eternity after an explosion at Sheriff Hill Colliery; while Christmas Eve 1831 saw the first outbreak of cholera in Gateshead, with its first victim, Mary Hymers of Bottle Bank, being described as a 'rag gatherer of depraved habits'. On a happier note, the first elections to the new Gateshead Council were held on Boxing Day 1835, with Gateshead's first mayor, George Hawks, being elected on New Year's Day. Before the formation of the council, Gateshead was governed by a body of men called the Four and Twenty. The beadle who was responsible for summoning them to meetings was paid 2 guineas every year and 'furnished with a good cloth coate every Christmas'.

X-rays

X-ray photographic tubes were manufactured as early as 1897 at the Sunbeam Lamp Company's premises at Park House in Gateshead. In 1937, a new X-ray plant at the Children's Hospital was provided through a grant of £620 by members of Vickers Armstrong Employees Medical Fund. Today, X-rays are carried out at the Queen Elizabeth Hospital, Blaydon Primary Care Centre and Trinity Square Medical Centre. Together these carry out approximately 165,000 examinations each year.

Y

Yeshiva

Jewish people had lived in Gateshead for much of the nineteenth century, but it was not until the arrival of Zachariah Bernstone in 1881 from Newcastle and Eliezer Adler in 1887 that a fully fledged Jewish community began to develop here. In 1912, the Blechener Shul, the 'tin shed' synagogue, was built on Corbitt Street.

In 1925, Rabbi Dovid Dryan, from Eastern Europe, was appointed as Gateshead's shochet (ritual slaughterer and teacher). This was a turning point in Gateshead's development as a Jewish centre for learning as he had a dream of establishing a

Gateshead's Yeshiva.

Talmudic education centre (Yeshiva) in the town. In 1929, three students began studying in the synagogue, with the first Rosh Yeshiva (head) being Rabbi Nachman Dovid Landynski, a notable scholar. He gradually and energetically built interest and student numbers rose. Refugees from Hitler's 1933 Germany applied to Gateshead's Yeshiva and, although there was no formal accommodation for them, many lodged with local families. By 1939, over 600 had arrived in Gateshead. Slowly, numbers and buildings expanded until in 1961 a new building in Windermere Street West was erected to house a new hall for study and prayer, with a dining room and kitchens. Residential and study extensions followed: Clore House (1963), Sebba House (1992), Tiferes Yonata (1997) and then lecture rooms.

In Gateshead today there is a complete set of educational institutions: nurseries (ohel rivka), primary and secondary schools to six yeshivot (plural of yeshiva) and four kollels (institutes of higher rabbinic learning). The Yeshiva is now world famous and has over 300 students who come from all over the world to study in Gateshead.

YMCA

The Young Men's Christian Association was founded by Sir George William in 1844 in London, with headquarters today in Geneva. The first Gateshead branch was opened in Catherine Terrace in 1885, but closed around four years later. The next branch to be formed was for homeless boys in 1919 and was based in premises adjacent to Windmill Hills School. This was taken over by Gateshead Council in 1937. New headquarters were opened in Belle Vue Terrace in 1947 with funds provided by Sir Arthur Munro Sutherland, a local shipping magnate. These had to be demolished due to road redevelopment, and in 1964 Queen Elizabeth, the Queen Mother opened new premises in the Bewick Assembly Rooms. Just five years later these too were closed and there is now no YMCA in Gateshead.

Z

Zilliacus, Konnie (1894–1967)

Konnie Zilliacus was Gateshead's popular Labour MP from 1945 to 1949. He was of Finnish and American parentage, born in Japan, and spoke nine languages fluently. During the First World War he worked as an orderly for a French medical unit near the front line, but after being invalided out he returned to Britain and worked for two Liberal Party MPs. He later found work as the British envoy to the League of Nations and was Geneva's official interpreter for visiting Russians. He worked diligently for the League of Nations to prevent war, but resigned after the Nazi invasion of Czechoslovakia. During the Second World War he worked for the Ministry of Information. In 1945, he was elected as MP for Gateshead, defeating the sitting member, Thomas Magnay, by a substantial majority. Suspected of Russian sympathies and very critical of government foreign policy, Zilliacus was expelled from the Labour Party in 1949, so stood as an independent candidate for Gateshead East the following year. In this, however, he was unsuccessful, although he later became MP for Manchester Gorton, having been readmitted to the Labour Party in 1952.

Zion Chapel

Situated on Sheriff Hill and now converted to residential use, this little chapel opened in 1836 as the Zion New Connexion Chapel. A schoolroom and a vestry designed by Thomas Reay were added to the rear in 1883. The building was built of local sandstone in an Italian style and was described as a 'small but handsome building'. It could seat 200 people.

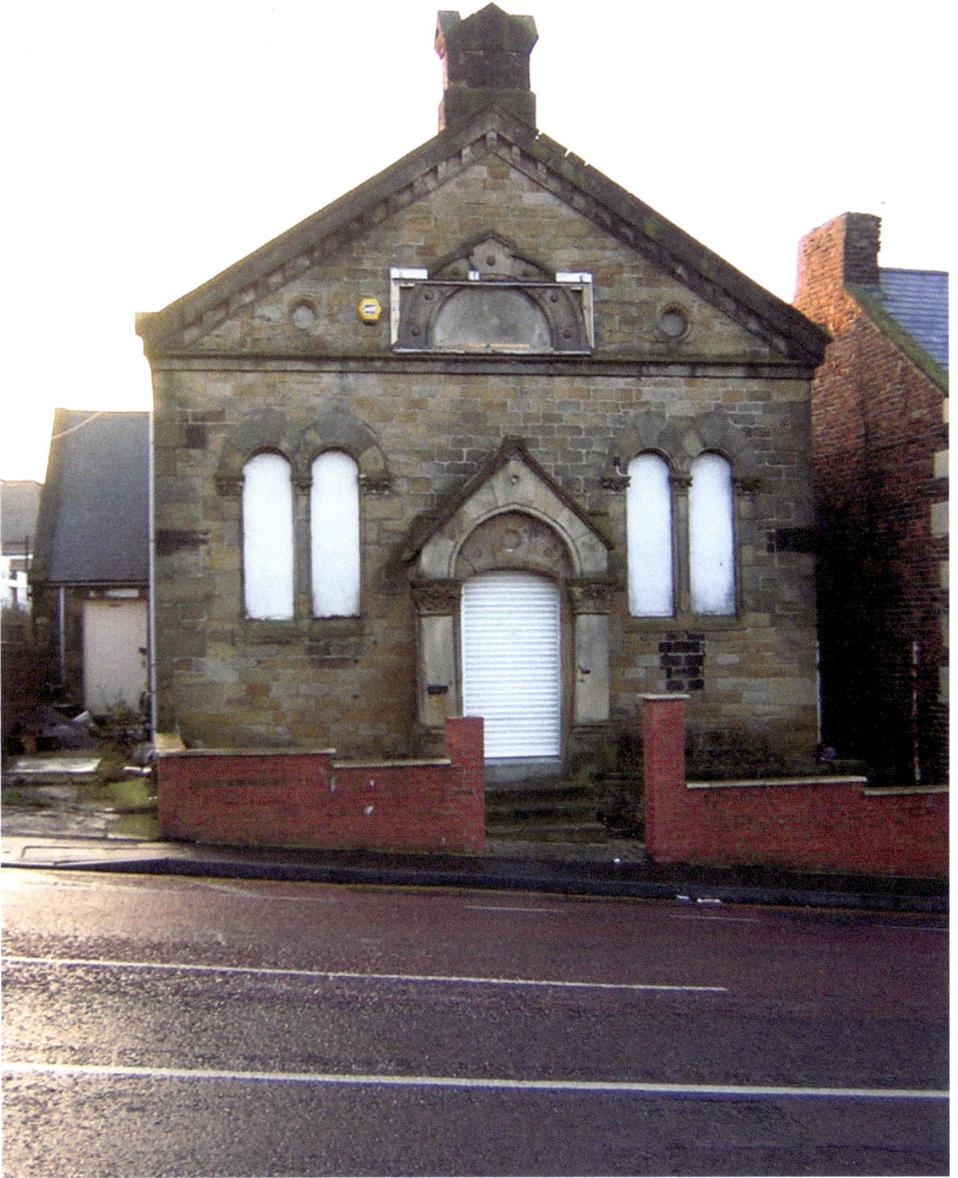

Zion Chapel. (Courtesy of Val Kirkley)

Acknowledgements

We would like to thank everyone who has helped us in any way while writing this book. We are grateful to Peter Bladon, Bob Dixon, Trevor Ermel, Baroness Joyce Quin and Helen Ward. Special thanks go to Duncan Hall for his restoration work on some of the images, and Gateshead Central Library and the Tyneside Cinema for their assistance with images.

About the Authors

The book's three authors have very different backgrounds, but all have a common interest and passion for researching Gateshead's rich history.

Sandra Brack has been interested in local history for over thirty years and is secretary of Gateshead Local History Society. She is the author and co-author of two books on *Gateshead's Grand Houses*, and co-author of two walking history books.

Gateshead Local History Society committee member Margaret Hall worked for BBC TV for almost forty years on regional news magazine programme *Look North* at their Newcastle studios. She was involved in a number of roles including news copy taker, floor manager and news transmission assistant. Margaret is also a co-author of *Gateshead Grand Houses Revisited*.

Anthea Lang was formerly local history and heritage manager for Gateshead Council and is the chair of Gateshead Local History Society. Anthea has written six local history books.

This is the second book the authors have written for Amberley Publishing, their first being *Gateshead From Old Photographs*, which was published in 2015.